SPACE

FROM NEAR-EARTH ORBIT TO THE FAR REACHES OF THE UNIVERSE

Publications International, Ltd.

Let's get social!

 @Publications_International

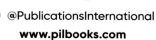 @PublicationsInternational

www.pilbooks.com

Step into the Void

From ancient structures built to track planetary motion to the latest photos transmitted from NASA's billion-dollar rovers on Mars, humankind has come a long way in its collective understanding of the cosmos. Thanks to many centuries of scientists who've built upon the work of those who came before, we have an unfathomably vast catalog of astronomical information available to us—and it's expanding almost as fast as space itself.

Space is a visual voyage through the universe. From our familiar neighboring planets to the far edges of our galaxy and beyond, this book will take you through what we currently know and how we came to know it. You'll learn about important historical figures, inventions, and monuments, the life cycles of stars, the cutting-edge technology currently used to track and photograph celestial objects, and more.

We all know what it's like to look up at the stars and feel a sense of wonder. Now get ready to explore just what makes the night sky so magnificent.

Table of Contents

Look Up 6

Recorded in Stone 10

Through Modern Eyes 16

The 20th Century 21

The View from Space 34

Hubble Space Telescope 46

Liftoff 54

Space Shuttle 64

Space Tourism 72

Looking at Earth 74

Step into the Void 84

International Space Station 94

The Moon 106

Mercury 128

Venus	134
Mars	140
A Ring of Rocks	154
Jupiter	160
Saturn	182
Uranus	206
Neptune	210
Dwarf Planets	214
Comets	220
Shooting Stars	232
The Sun	238
Stars	252
The Interstellar Medium	288
Galaxies	300
The Milky Way Galaxy	314

Look Up

The mysterious wheeling of tiny bright lights in the night sky has always been a source of curiosity for humans. While we can only imagine what our prehistoric ancestors were thinking when they looked up into the night, we know that they felt compelled to create artifacts to record specific astronomical events. Star maps dating back over 30,000 years have been found drawn on cave walls and carved into bones. Many cultures built structures dedicated solely to the observation of the sky. Others created massive stone edifices to mark and measure important phenomena like solstices. Their feats of technological ingenuity still amaze us today.

As early as the third millennium BC, Babylonian astronomers were recording their observations of planetary movements. Chinese artifacts dating back to the second millennium BC recorded eclipses and novas. India's earliest known text on astronomy, the *Vedanga Jyotisha*, dates back to about 1400 BC. By the time the Greeks developed it into a branch of mathematics, astronomy was a firmly established discipline in the ancient world.

Fascination with the cosmos has remained constant throughout history, but now for the first time we are able to satisfy our curiosity. Recent decades have seen multiple revolutions in the tools and technology we use to view and understand the universe. Thanks to these advances we are able to see farther and deeper into the sky than ever before.

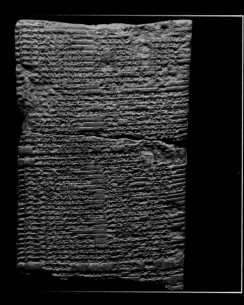

Numerous Sumerian cuneiform tablets have been found to contain geometric calculations predicting the movements of planets like Jupiter and Venus.

The Nebra Sky Disc was unearthed from a burial hoard in Germany in 1999. This 3,600-year-old disc is a kind of astronomical clock, used to harmonize the discrepancy between solar and lunar years. The cluster of seven stars is probably the Pleiades.

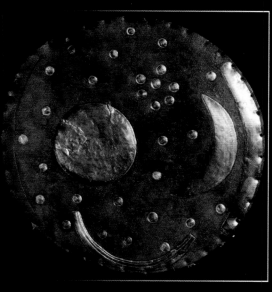

An example of a Bronze Age "golden hat." These artifacts originated in France, Switzerland, and Germany. They appear to contain codified calendrical information— probably to assist in tracking solar and lunar progressions.

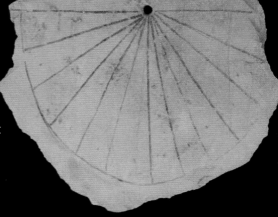

This Egyptian sundial dates back to around the 13th Century BC. This flat piece of limestone has been etched with a black semicircle divided into twelve sections. A small hollow in the center served as a post hole for a bolt which would have cast a shadow to show the time of day.

9

Recorded in Stone

The earliest buildings dedicated to astronomical observations were both pragmatic and ritualistic. Communities could plan important annual events like planting, harvesting, and storing by determining the exact dates of the solstices and equinoxes. These celestial cycles were also connected to the belief systems that dealt with life, death, renewal, and growth. Not only were the first astronomers observers, they were also participants in a cosmic drama. They watched—and encouraged—the return of the Sun in the spring. They tracked the Moon monthly and worshipped it as well. Stars, wandering planets, streaking comets—all of these held astronomical significance.

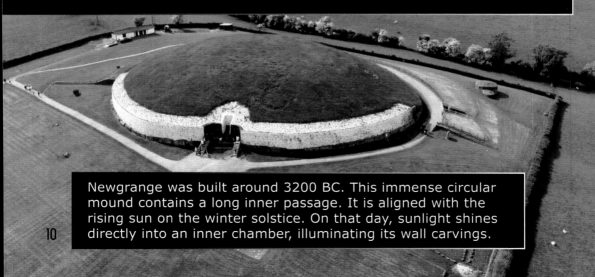

Newgrange was built around 3200 BC. This immense circular mound contains a long inner passage. It is aligned with the rising sun on the winter solstice. On that day, sunlight shines directly into an inner chamber, illuminating its wall carvings.

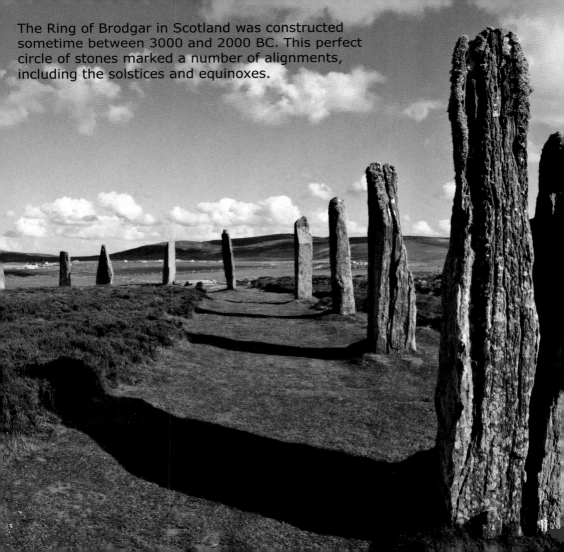

The Ring of Brodgar in Scotland was constructed sometime between 3000 and 2000 BC. This perfect circle of stones marked a number of alignments, including the solstices and equinoxes.

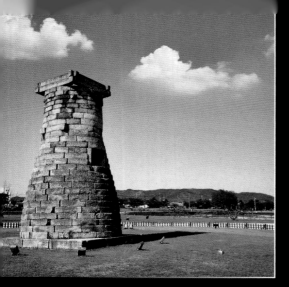

South Korea's Cheomseongdae is the oldest existing astronomical observatory in Asia. It was built in the seventh century AD. In addition to being used as an observation platform, it acted like the gnomon of a sundial. Its window was also aligned to guide sunlight to the interior, marking the occurrence of the equinoxes.

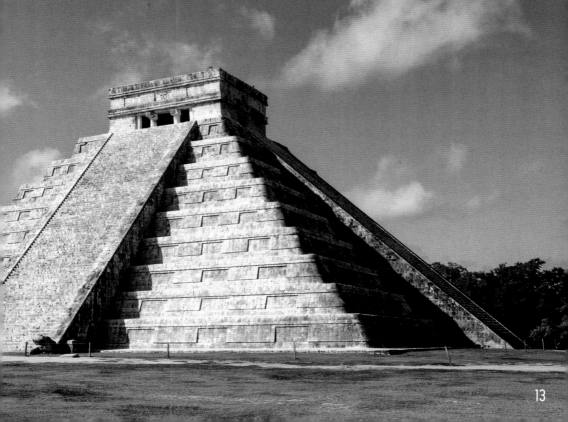

Built around 1000 AD, the pyramidal structure known as El Castillo is set within the ruins of the Mayan city Chichén Itzá. The pyramid served a number of astronomical functions, but is now known for an event that occurs twice a year at the equinoxes. At sunset, the gathering shadows give the appearance of a giant snake body undulating down the steps. At the bottom, the shadowy body joins with a stone snake head.

13

Stonehenge was built in stages, beginning some time in the third millennium BC. It is uncertain whether the site was constructed for astronomical observation, though the stones clearly mark both solstices. The winter solstice was probably ritually observed by the monument's builders.

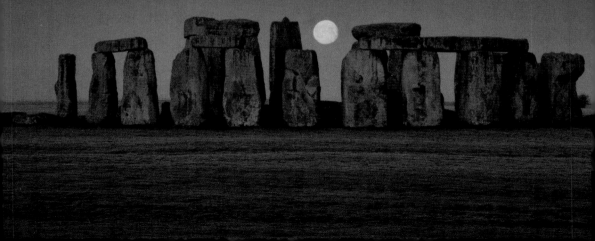

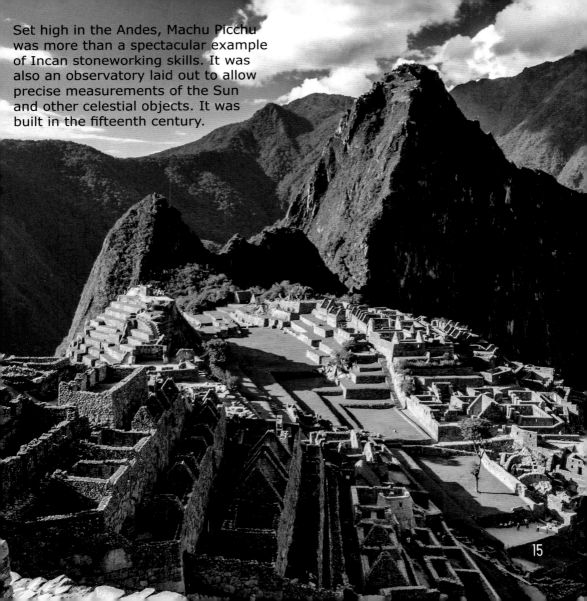

Set high in the Andes, Machu Picchu was more than a spectacular example of Incan stoneworking skills. It was also an observatory laid out to allow precise measurements of the Sun and other celestial objects. It was built in the fifteenth century.

15

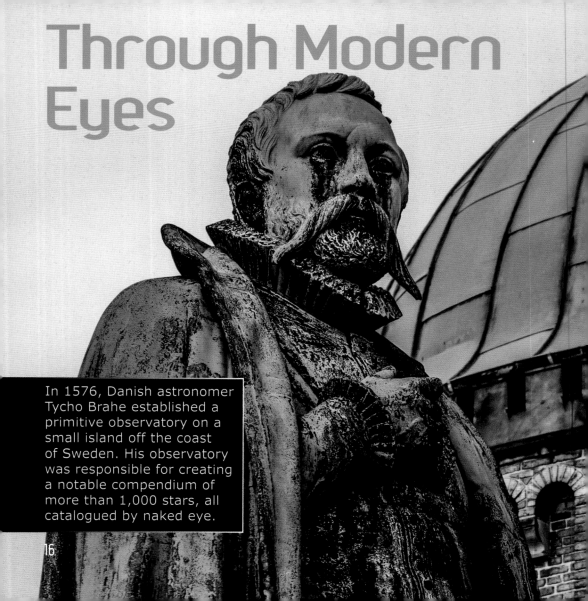

Through Modern Eyes

In 1576, Danish astronomer Tycho Brahe established a primitive observatory on a small island off the coast of Sweden. His observatory was responsible for creating a notable compendium of more than 1,000 stars, all catalogued by naked eye.

Astronomy may be a science that has been practiced by people all over the world for thousands of years, but modern, ground-based observatories are unlike anything that has come before. Modern observatories began to take shape several centuries ago, thanks largely to the work of many influential mathematicians and astronomers whose discoveries built upon each other.

17

Several decades after Tycho Brahe's work, Galileo Galilei devised the first optical telescope. This invention marked a major milestone in the history of astronomical observation. Optical telescopes were improved throughout the next century, with Isaac Newton's famous invention the reflector telescope (a telescope that employs curved mirrors) in 1668.

GALILEO

Influenced by the work of Tycho Brahe and other astronomers that came before him, Johannes Kepler discovered three major laws of planetary motion, the first and most famous of which being that the Earth and other planets travel around the sun in elliptical orbits.

By 1781, William Herschel was using a telescope powerful enough to discover Uranus. By increments, astronomers developed the technology necessary to look farther into the night sky.

The 20th Century

Observatories proliferated around the world in the 20th century, becoming a source of pride to their communities. Facilities like Yerkes Observatory represented a recognition of the need for astronomical equipment to be housed with supporting laboratory space. Yerkes was an important center of research into the nature of globular clusters and the interstellar medium. While most observatories are affiliated with particular institutions, Kitt Peak National Observatory is notable for being open to astronomers across the nation. Griffith Observatory has been free and open to the public since its opening in 1935.

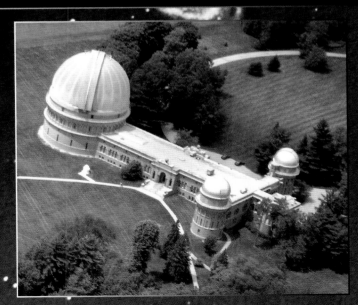

An aerial view of the Yerkes Observatory

Yerkes Observatory

Location: Williams Bay, Wisconsin
Yerkes Observatory is owned by the University of Chicago. The facility is often called "the birthplace of modern astrophysics." Edwin Hubble studied at Yerkes while working on his doctorate. The observatory closed its doors in 2018.

Kitt Peak National Observatory

Location: Schuk Toak District (outside Tuscon), Arizona
Kitt Peak is part of the National Optical Astronomy Observatory, one of the largest collections of observatories in the northern hemisphere. Opened in 1964, the observatory functions as a national center for optical astronomy.

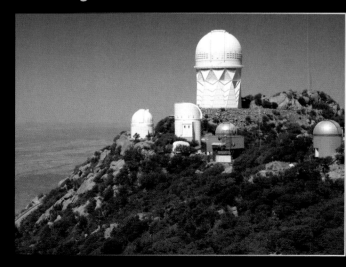

Griffith Observatory

Location: Los Angeles, California
First opened in 1935, Griffith Observatory's mission has always
been to make astronomy available to the public and to inspire
people to "observe, ponder, and understand the sky." It was
one of the first American institutions devoted to public science.

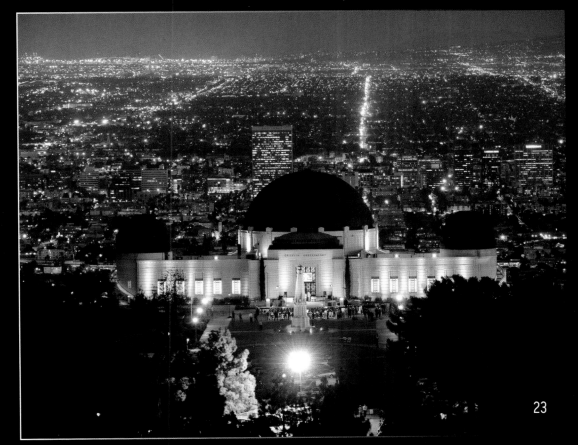

23

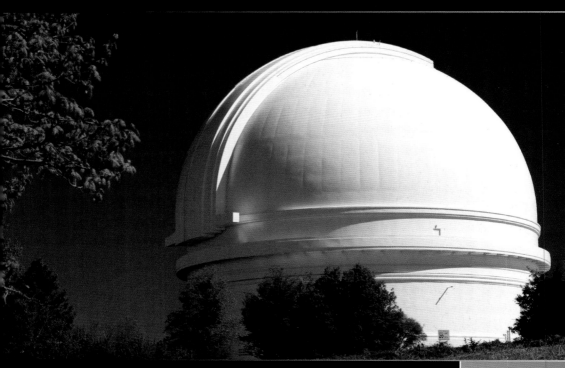

Palomar Observatory

Location: San Diego County, California
Construction began in 1936, and was completed in 1948.
The 200-inch telescope was the largest in the world for
decades. It was immediately able to observe faint and distant
galaxies. Observations made in the 1960s revealed that
quasars were the most distant objects in the universe. The
observatory is still active and continues to be upgraded.

Mauna Kea Observatories

Location: Summit of Mauna Kea, Hawaii
The site of this major collection of telescopes and research facilities
was first used for astronomical observations in 1964. The collection
includes three large reflectors, several submillimeter-wavelength
telescopes, a radio astronomy facility, and the multimirror Keck
telescope. At 10 meters, the Keck is the largest reflector in the world.

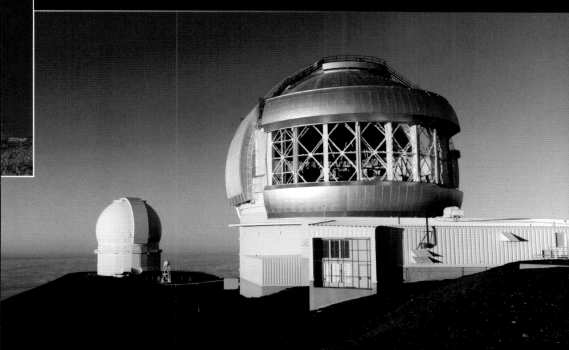

Completed in 1963, this massive radio telescope was used for research in radio and radar astronomy as well as atmospheric science. Arecibo's long list of achievements includes finding ice at the poles of Mercury, mapping the surface of Venus, pinpointing the rotation rate of Mercury, and discovering the first binary pulsar. The telescope collapsed on its own in December of 2020, just a few months after the U.S. National Science Foundation deemed the platform too unstable to safely repair.

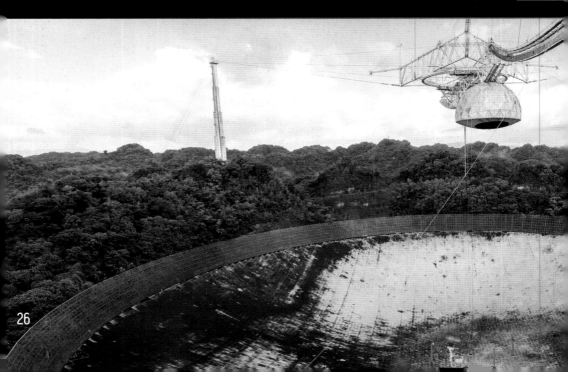

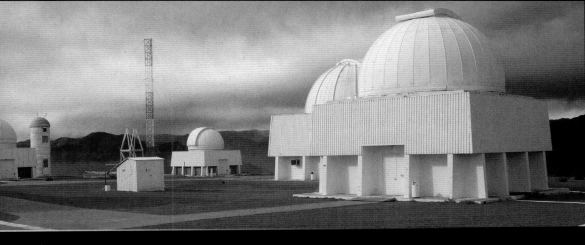

Cerro Tololo Inter-American Observatory

Location: Coquimbo
Region, northern Chile
This complex of telescopes and
instruments is notable for its
observations of the central Milky
Way and the Magellanic Clouds. In
2017, a team of researchers working
at CTIO discovered 12 new moons
circling Jupiter. The observatory
has been functioning since 1965.

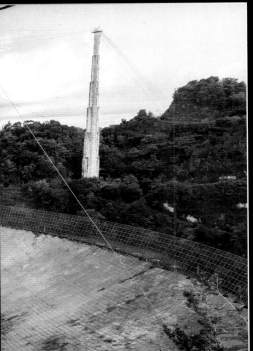

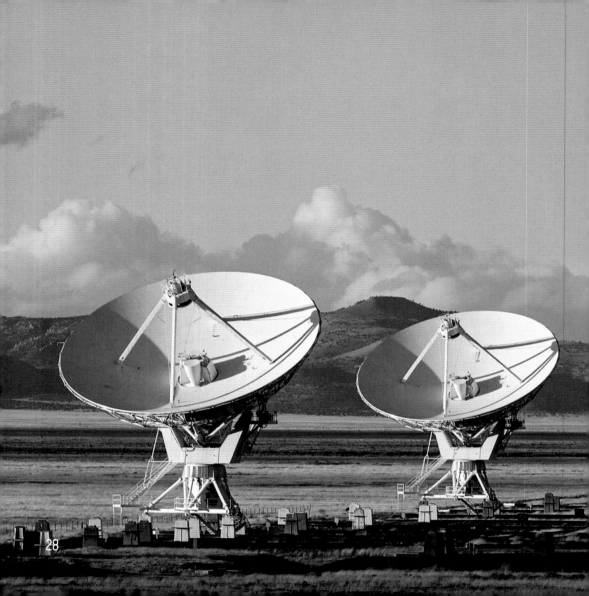

28

The Very Large Array

Location: Socorro, New Mexico
Completed in 1980, the Very Large Array consists of 27 radio antennas shaped in a Y configuration. One of the most important radio observatories in the world, the VLA is truly multipurpose. It is capable of looking into the shrouded center of the Milky Way, seeing radio atmospheres around stars, pinpointing plasma ejections from supermassive black holes, and tracking spacecraft in our solar system.

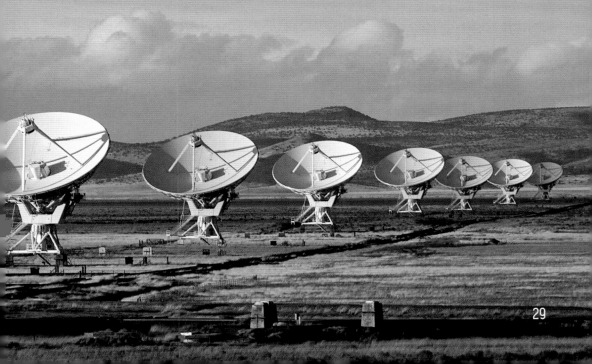

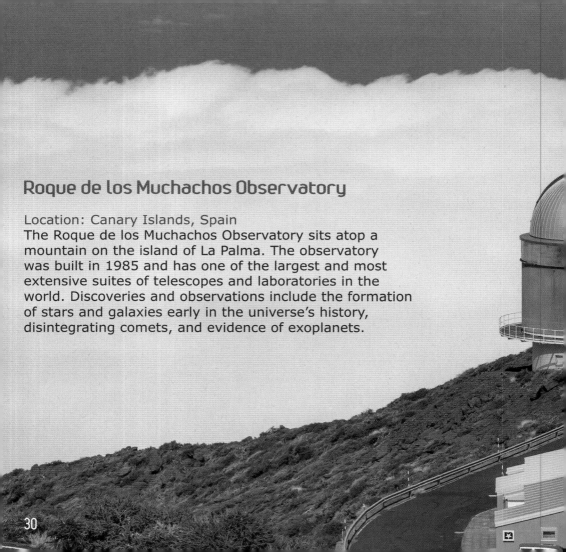

Roque de los Muchachos Observatory

Location: Canary Islands, Spain
The Roque de los Muchachos Observatory sits atop a mountain on the island of La Palma. The observatory was built in 1985 and has one of the largest and most extensive suites of telescopes and laboratories in the world. Discoveries and observations include the formation of stars and galaxies early in the universe's history, disintegrating comets, and evidence of exoplanets.

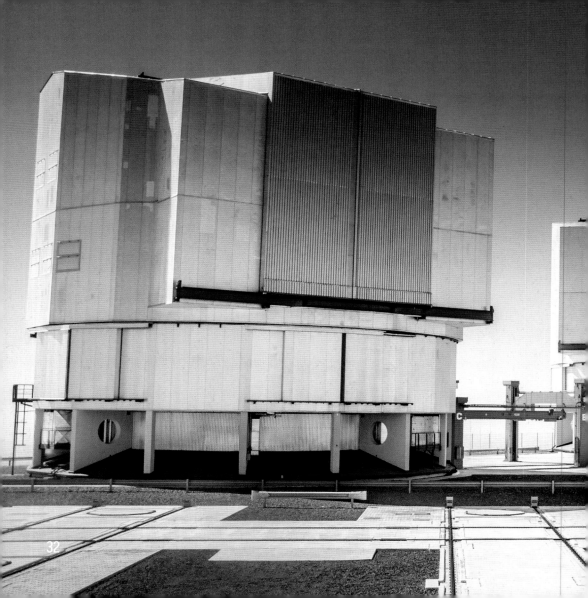

The Very Large Telescope

Location: Cerro Paranal, northern Chile
The Very Large Telescope was completed in 1998 and consists of eight separate telescopes that can function individually or together. Among other feats, it has tracked individual stars moving around the black hole at the center of our galaxy, observed the afterglow of the farthest known gamma-ray burst, and captured the first visual image of an exoplanet.

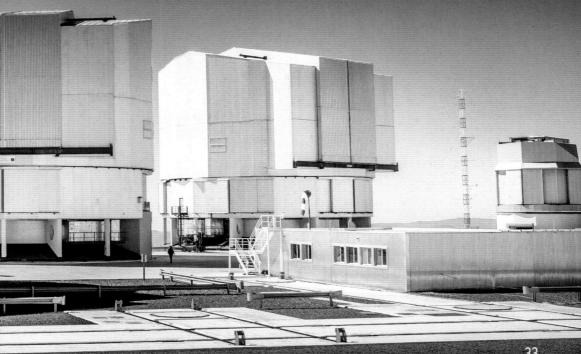

The View from Space

Space-based observatories represent another leap forward for astronomy. These observatories avoid some of the problems ground-based observatories encounter, such as light pollution. Great Britain launched the first astronomical satellite (Ariel 1) in 1962. NASA launched its first group of space observatories between 1966 and 1972. These four satellites, known collectively as the Orbiting Astronomical Observatory (OAO), helped convince the scientific community of the benefits of observing the cosmos above the Earth's atmosphere. The OAO program was a precursor to later observatories like the Hubble Space Telescope. A large number of the images shown in this book come from space observatories.

Chandra X-ray Observatory

Launched: via space shuttle, 1999
Chandra focuses on the X-ray
segment of the electromagnetic
spectrum. It observes black holes,
quasars, supernovas, and high-
temperature gases. Chandra's images
are 25 times sharper than those of
the best previous X-ray telescope.

Spitzer Space Telescope

Launched: 2003
Spitzer focuses on the infrared segment of the electromagnetic spectrum.

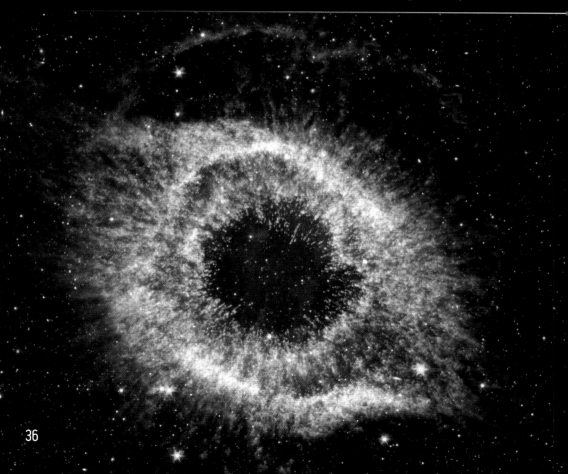

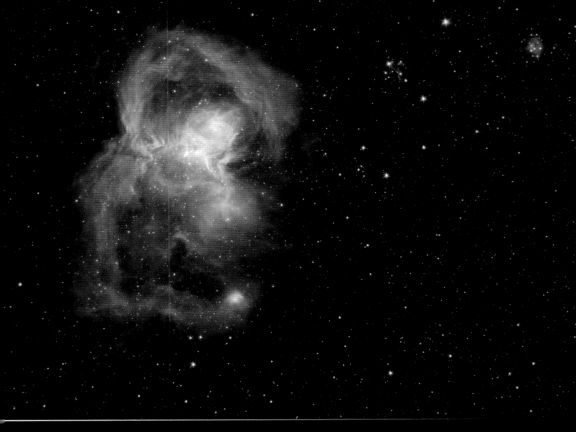

Spitzer is especially important because the Earth's atmosphere blocks most of the infrared radiation originating in outer space. Spitzer is helpful in studying cooler interstellar objects too dim to be detected via visible light. Since infrared light can penetrate clouds of gas and dust, Spitzer is able to see through them into centers of galaxies and newly forming solar systems. This image of the Helix Nebula was taken on the fourth anniversary of the launch of the telescope.

Galaxy Evolution Explorer (GALEX)

Launched: 2003

The purpose of GALEX was to make observations of star formations in the ultraviolet spectrum. It also took distance measurements of hundreds of thousands of galaxies. These observations spanned 10 billion years of cosmic history. GALEX contributed to our understanding of the basic structures of the universe. It captured this image of the Helix Nebula's ultraviolet glow in 2012.

Fermi Gamma-ray Space Telescope

Launched: 2008
Fermi observes the universe via gamma-rays, the most energetic form of radiation known. Fermi's observations help answer questions about black holes, pulsars, and cosmic rays. It is also assisting physicists to study subatomic particles at energies much higher than any observed via ground-based particle accelerators. This image shows the Cassiopeia A supernova remnant emitting radiation.

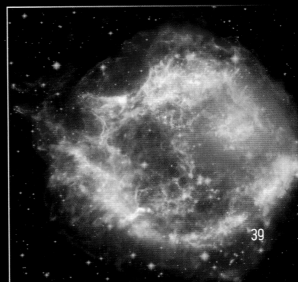

Kepler space telescope

Launched: 2009
Kepler was launched to survey
segments of the Milky Way Galaxy
near our solar system to look for
exoplanets. During its mission it
confirmed over 2,000 exoplanets
and gave us extensive information
on the nature of other planetary
systems. Kepler used a photometer—
the sole instrument used to monitor
distant star systems. The spacecraft
ran out of fuel on October 30th,
2018, after years of service that
extended far longer than its original
four-year mission. The image on
the right is the first light image
Kepler took during its mission, and
contains about 4.5 million stars.

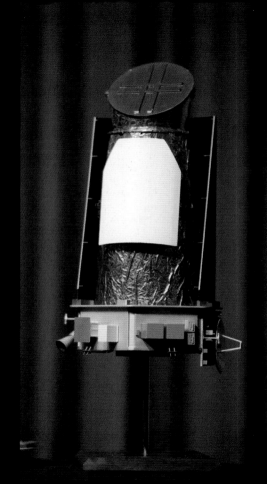

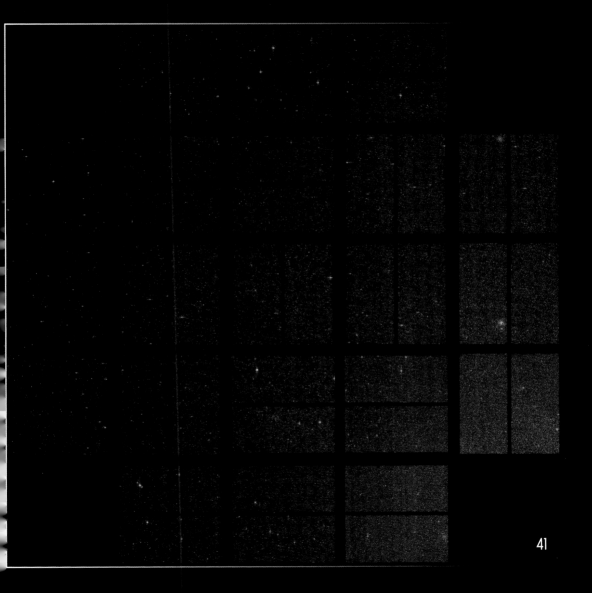

Wide-field Infrared Survey Explorer (WISE)

Launched: 2009
WISE's primary purpose was to scan the entire sky in
the infrared spectrum. WISE located millions of potential
black holes obscured by dust, discovered a new class of
cool stars (brown dwarfs), and ruled out the theory of a
"Planet X" in the outer limits of the solar system orbiting
the Sun. After it completed its surveys it was given a new
task: locating near-Earth objects (NEOs), particularly
asteroids that might intersect with Earth's orbit. This
infrared image of a star-forming cloud was taken by WISE.

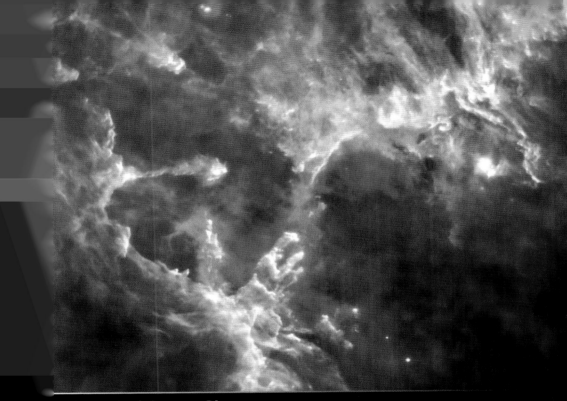

Herschel Space Observatory

Launched: 2009
Covering a spectral range from far infrared to submillimeter, the European Space Agency's Herschel Space Observatory boasted the largest single mirror for a space telescope. Herschel looked at how galaxies evolved in the early universe, how stars form, and investigated the molecular chemistry of celestial bodies like comets, moons, and planets. Herschel took this image of the Eagle nebula in 2012. It ceased operating in 2013.

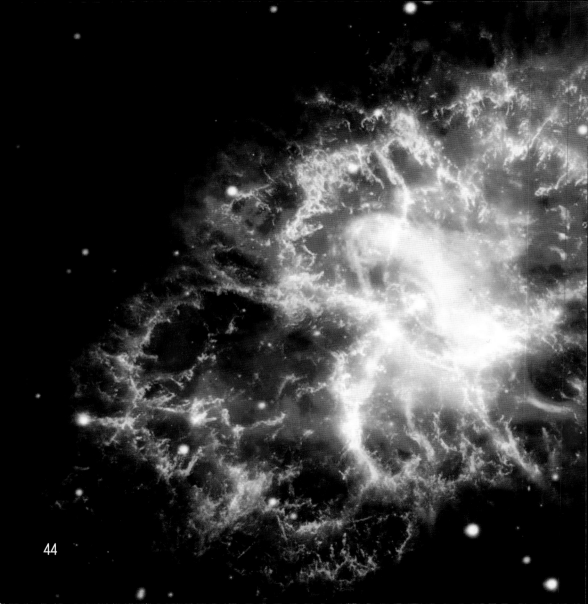

44

By combining data from telescopes spanning nearly the entire breadth of the electromagnetic system—including the Very Large Array, the Chandra X-ray Observatory, the Hubble Space Telescope, and the Spitzer Space Telescope—astronomers have produced this highly detailed image of the Crab Nebula.

Hubble Space Telescope

The Hubble Space Telescope was launched in 1990. It was the first major optical telescope to be put in space, and orbits the Earth 340 miles above the surface. With this unobstructed view, it has taken some of the most spectacular images of the cosmos humans have ever seen. Hubble makes observations in visible, infrared, and ultraviolet light. Its cameras and spectrographs catch light that has been traveling since the universe was young. Hubble's measurements have helped scientists determine that the universe is 13.8 billion years old. Hubble's observations have also shown that not only is the universe expanding, but that its expansion rate is accelerating.

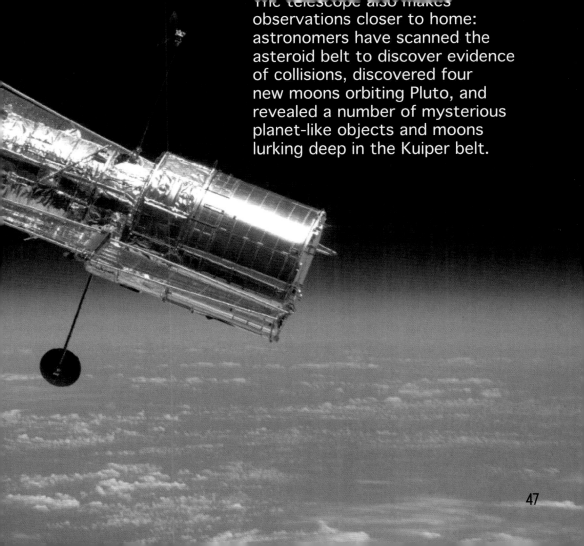

The telescope also makes observations closer to home: astronomers have scanned the asteroid belt to discover evidence of collisions, discovered four new moons orbiting Pluto, and revealed a number of mysterious planet-like objects and moons lurking deep in the Kuiper belt.

47

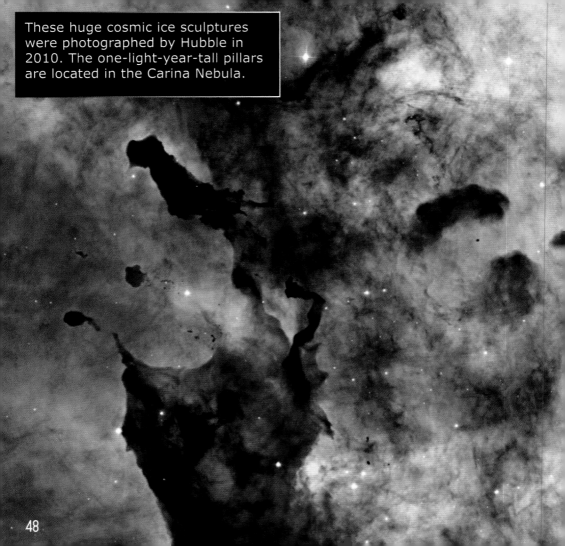

These huge cosmic ice sculptures were photographed by Hubble in 2010. The one-light-year-tall pillars are located in the Carina Nebula.

In 2017 Hubble took this image of part of the sky within the constellation Sagittarius. The color of each star depends on its surface temperature: the hottest stars are blue or white, while the cooler stars are redder.

Hubble photographed this "cosmic caterpillar" in 2017. What appears to be a fuzzy little friend is actually a light-year-long knot of dust and gas.

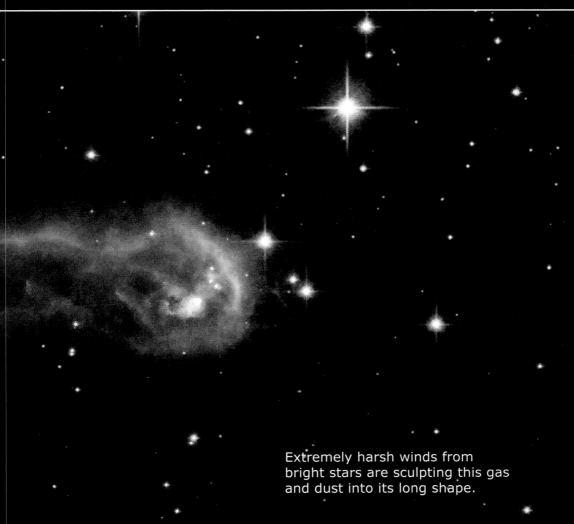

Extremely harsh winds from bright stars are sculpting this gas and dust into its long shape.

53

Liftoff

To get there, you need thrust—lots of it. NASA's Mercury project used Redstone and Atlas rockets. These rockets used ethyl alcohol fuel. The massive Saturn V rockets that shot astronauts to the Moon used different kinds of fuel for different boost stages. Kerosene, liquid oxygen (as an oxidizer), and liquid hydrogen were all used to supply thrust. These fuels continue to be used in modern rockets. The spectacular thrust accomplished in liftoffs also yields some spectacular visuals.

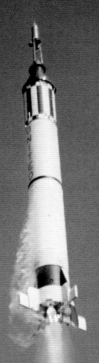

1961
The first manned spacecraft is launched from Cape Canaveral. The Mercury-Redstone 3 (Freedom 7) was piloted by astronaut Alan Shepard.

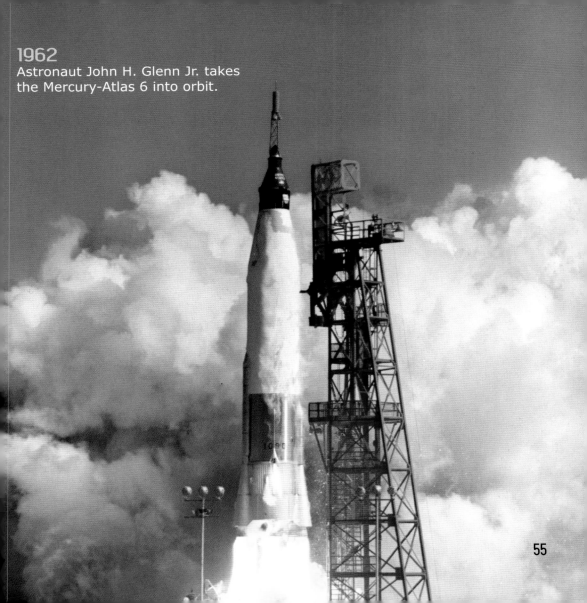

1962
Astronaut John H. Glenn Jr. takes
the Mercury-Atlas 6 into orbit.

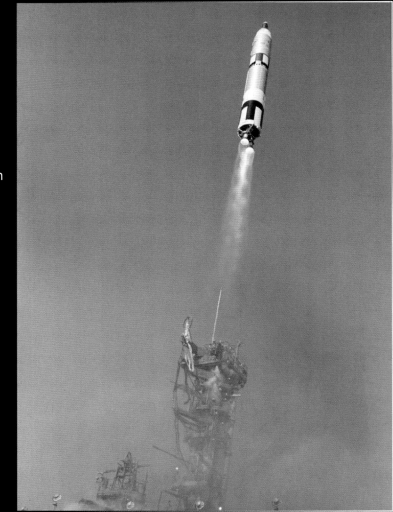

1966

A Titan II GLV (Gemini Launch Vehicle) carries Gemini astronauts Thomas P. Stafford and Eugene A. Cernan into orbit. The Gemini program was an important precursor to the Apollo landings.

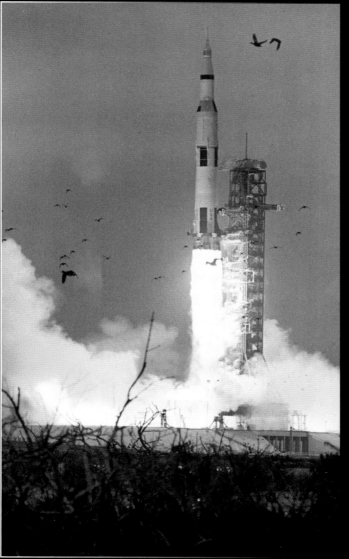

1968
A Saturn V launch vehicle carries astronauts James A. McDivitt, David R. Scott, and Russell L. Schweickart in Apollo 9 into orbit.

1969
A Saturn V launch vehicle sends Apollo 11, the first manned mission to the Moon, into the sky.

A Delta II rocket sends NASA's Dawn spacecraft on its way to visit objects in the asteroid belt.

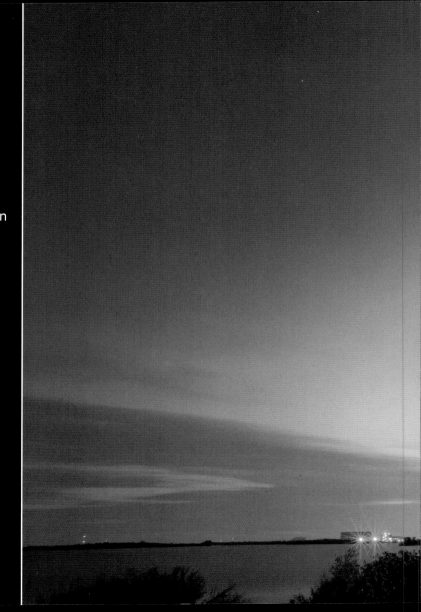

2018
The SpaceX Falcon 9 launch vehicle's early morning liftoff leaves an impressive trail.

61

2018

NASA's InSight (Interior Exploration using Seismic Investigations, Geodesy and Heat Transport) heads to Mars to study marsquakes. The mission will help scientists better understand how rocky planets form.

The Space Shuttle

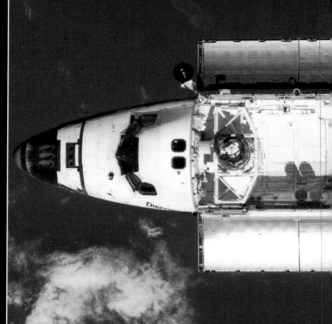

The shuttle program lasted from 1981 to 2011. In that time, its fleet made 21,152 Earth orbits and logged 542,398,878 miles. Each was capable of carrying a payload (food, flight tools, satellites, space suits, and other kinds of equipment) of about 60,000 pounds in its immense cargo bay. Shuttles launched and repaired satellites, provided astronauts with opportunities to conduct experiments, and ferried scientists and supplies to and from the International Space Station.

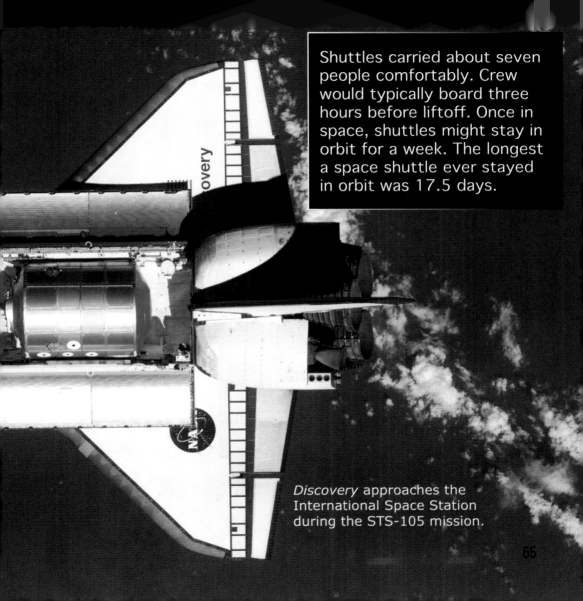

Shuttles carried about seven people comfortably. Crew would typically board three hours before liftoff. Once in space, shuttles might stay in orbit for a week. The longest a space shuttle ever stayed in orbit was 17.5 days.

Discovery approaches the International Space Station during the STS-105 mission.

Notable Numbers

Number of shuttles built: 6
Time to orbit: 8.5 minutes
Largest crew size: 8
Heaviest payload: 25 tons
Total number of crew
members: 852
Total time in space: 1,334 days

Length of cargo bay: 60 feet
Dockings with the International
Space Station: 37
Number of missions: 135
Landing speed at touchdown:
220 miles per hour

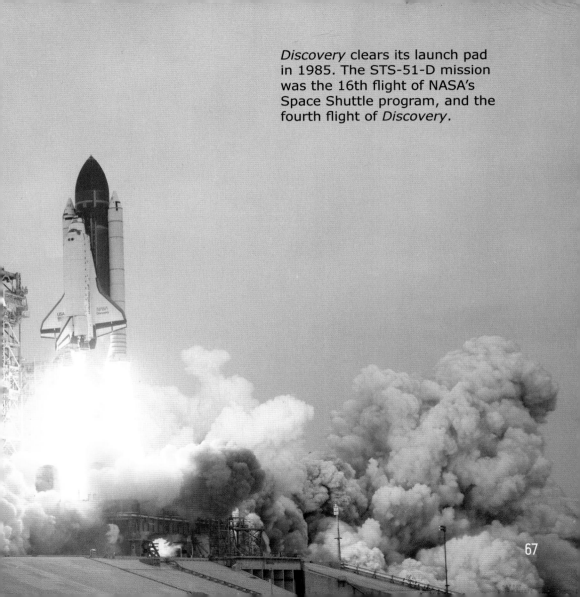

Discovery clears its launch pad in 1985. The STS-51-D mission was the 16th flight of NASA's Space Shuttle program, and the fourth flight of *Discovery*.

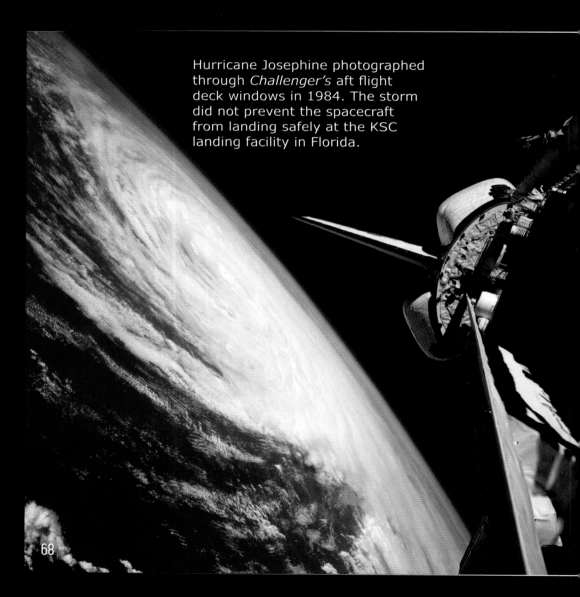

Hurricane Josephine photographed through *Challenger's* aft flight deck windows in 1984. The storm did not prevent the spacecraft from landing safely at the KSC landing facility in Florida.

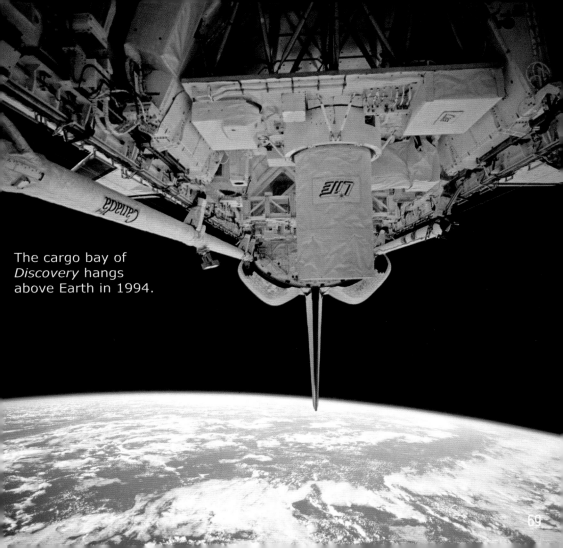

The cargo bay of
Discovery hangs
above Earth in 1994.

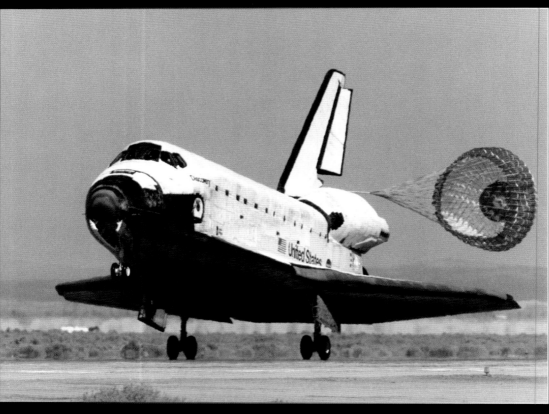

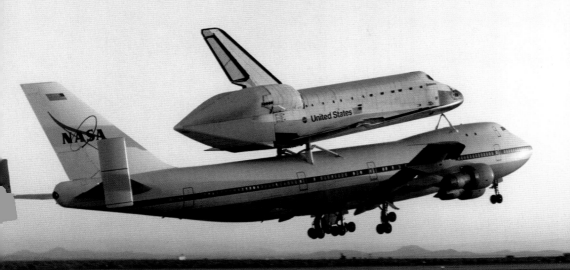

Endeavor departs Edwards Air Force Base
aboard a modified Boeing 747 in 2001.

Space Tourism

In 2001, an American engineer paid a reported $20 million to ride aboard a Russian Soyuz spacecraft to the International Space Station. Dennis Tito made history by becoming the first private citizen to fund his own trip into space, sparking a widespread interest in recreational space travel that has been growing ever since. Richard Branson's Virgin Galactic, Elon Musk's SpaceX, and Jeff Bezos's Blue Origin are all companies working toward making space tourism a regular part of the aviation industry.

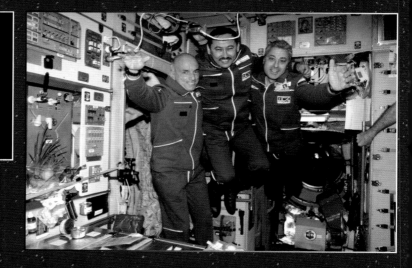

Dennis Tito (left) poses for a photo with crewmembers on the ISS. Tito's trip to space lasted a little over a week.

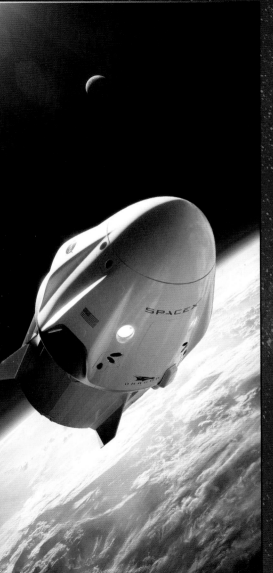

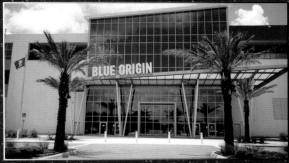

Blue Origin launch vehicle production facility in Cape Canaveral, Florida. Bezos's mission is to make access to space less expensive and more reliable through the use of reusable rockets. Founded in 2002, Blue Origin flew its first crewed mission on July 20, 2021. It has not yet begun commercial passenger flights.

This illustration depicts a SpaceX Crew Dragon spacecraft hovering above Earth. NASA is partnered with SpaceX to build a new generation of spacecraft capable of ferrying astronauts, cargo, and robotic explorers to and from space.

73

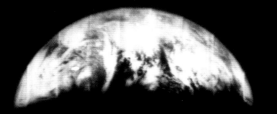

Looking at Earth

The first photograph of the Earth from space was a grainy black and white image taken in 1946. It was taken by a 35-millimeter camera that hitched a ride with a V-2 missile launched from New Mexico's White Sands Missile Range. The next year, a rocket 100 miles above the planet snapped a few more pictures. Over the next two decades, hundreds of images were taken as test flights and satellite launches proliferated. The Apollo missions gave us Earth photos taken by human hands.

In 1966, Lunar Orbiter I took this photo of the Earth while circling the Moon.

TIROS-1 was the first weather satellite to photograph the Earth in 1960.

FIRST TELEVISION PICTURE FROM SPACE
TIROS I SATELLITE APRIL 1, 1960

The first color photo of the
Earth taken by astronauts
from lunar orbit was snapped
on Christmas Eve, 1968.

Snapped in 1969, this image from the Apollo 11 spacecraft shows Earth above the moon's horizon.

Apollo 17 astronauts took this color photo of the entire planet in 1972. This iconic shot came to be called the "Blue Marble." It may be the most widely reproduced photograph in history.

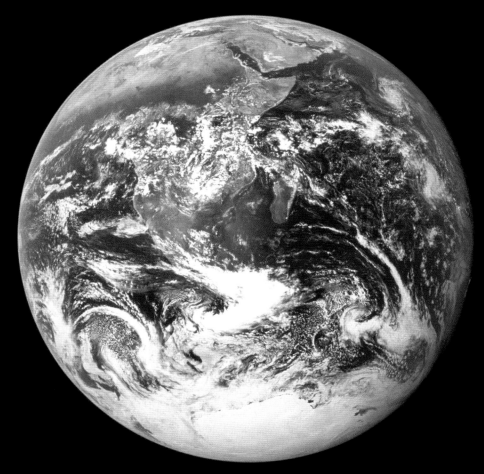

NASA's Voyager 1 was about four billion miles away when it turned its camera back toward Earth and snapped one final photo. This image, known as the "Pale Blue Dot," was taken in 1990. The Earth can barely be made out as a tiny speck about halfway down the brown band on the far right.

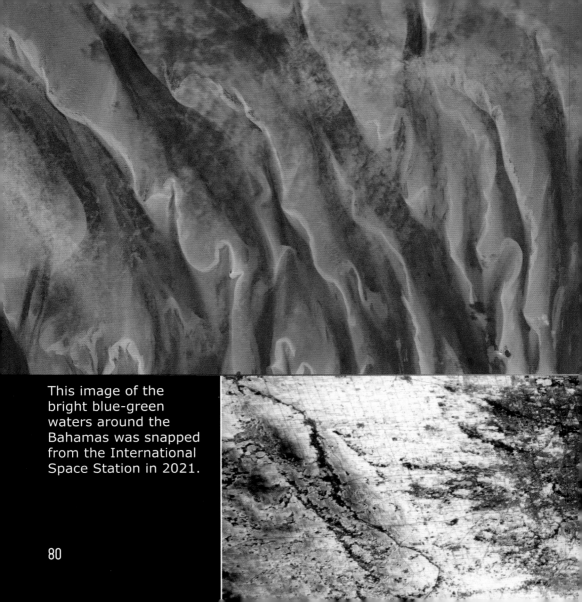

This image of the bright blue-green waters around the Bahamas was snapped from the International Space Station in 2021.

80

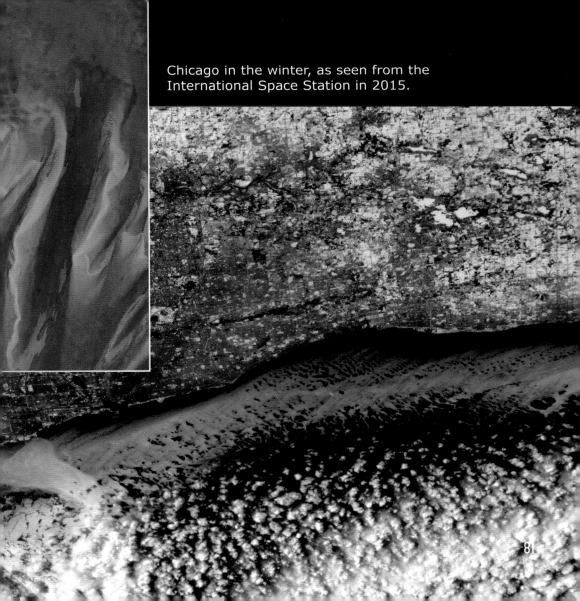

Chicago in the winter, as seen from the International Space Station in 2015.

81

A bright aurora shines over Earth's horizon.

Step into the Void

On June 3, 1965, astronaut Ed White left his Gemini 4 capsule and became the first American to perform EVA (extravehicular activity).

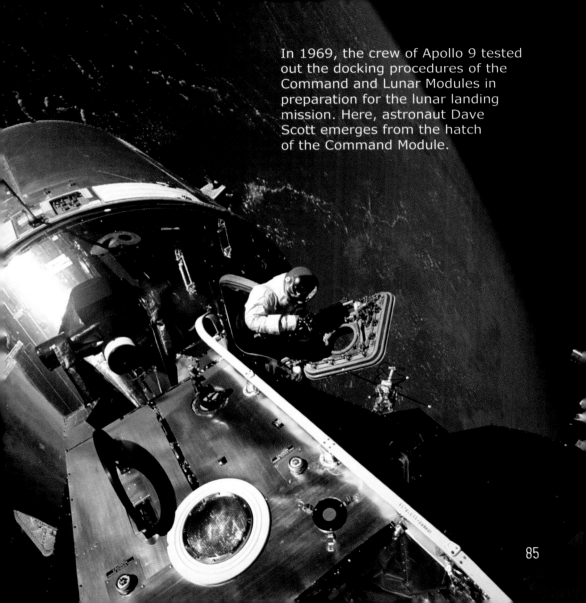

In 1969, the crew of Apollo 9 tested out the docking procedures of the Command and Lunar Modules in preparation for the lunar landing mission. Here, astronaut Dave Scott emerges from the hatch of the Command Module.

Skylab 3 pilot Jack R. Lousma pauses during equipment installation in 1973. The Earth's reflection is captured in his helmet visor.

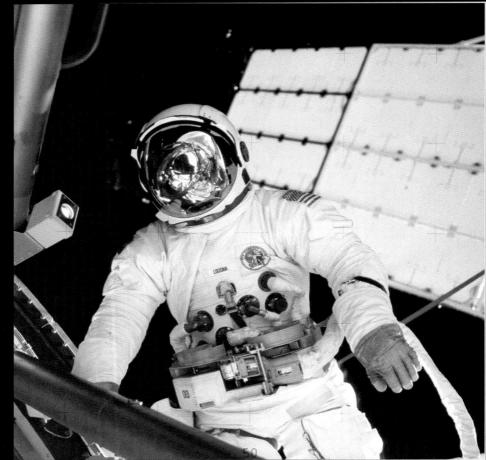

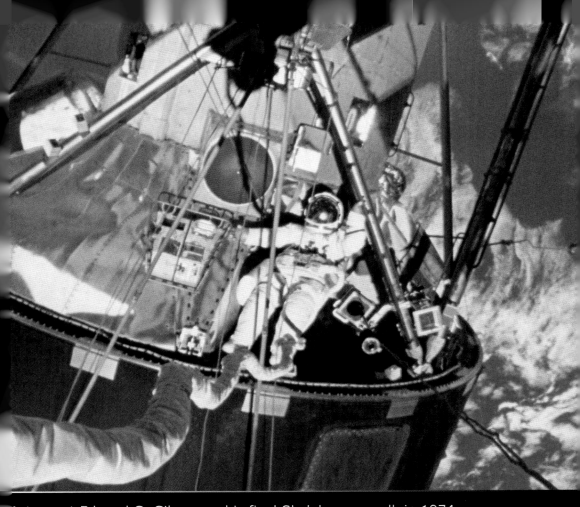

Astronaut Edward G. Gibson on his final Skylab spacewalk in 1974.

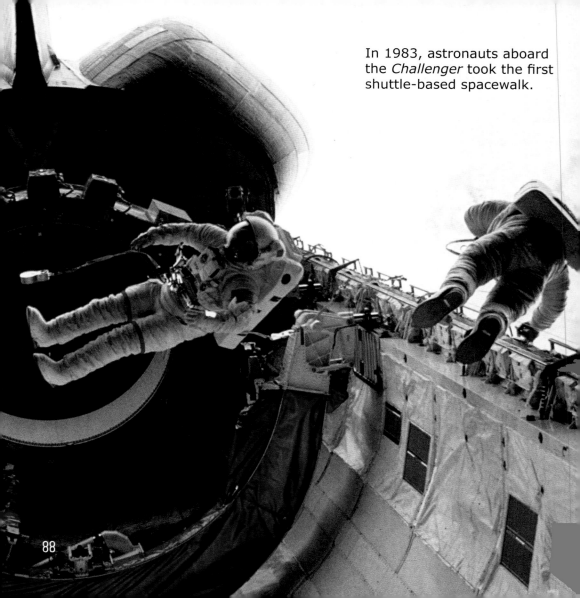

In 1983, astronauts aboard the *Challenger* took the first shuttle-based spacewalk.

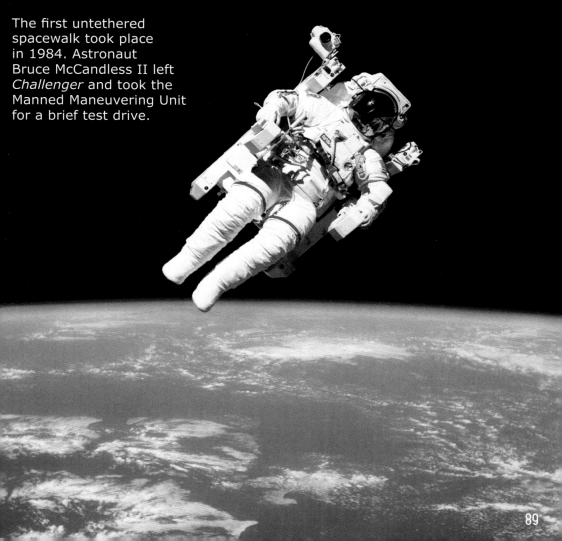

The first untethered spacewalk took place in 1984. Astronaut Bruce McCandless II left *Challenger* and took the Manned Maneuvering Unit for a brief test drive.

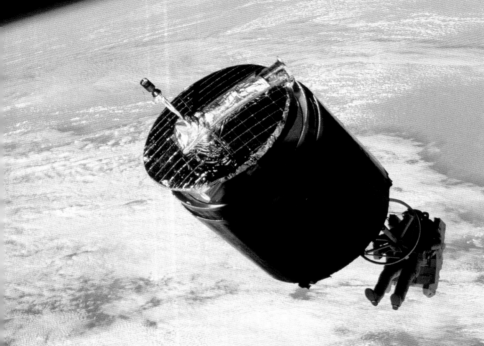

In 1984, astronaut Dale A. Gardner used the Manned Maneuvering Unit to dock with a satellite and stabilize it for capture. It was returned to Earth in the cargo bay of the space shuttle *Discovery*.

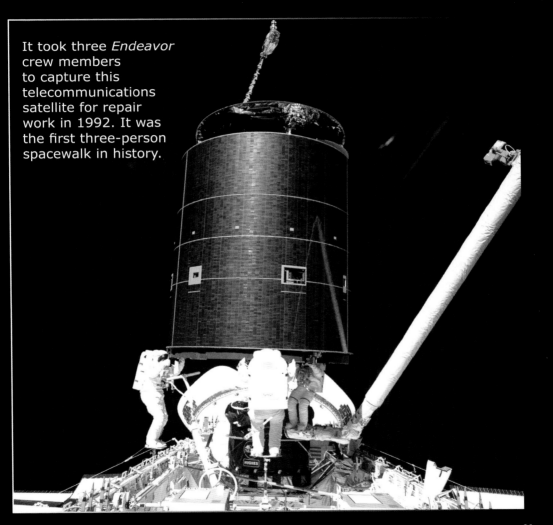

It took three *Endeavor* crew members to capture this telecommunications satellite for repair work in 1992. It was the first three-person spacewalk in history.

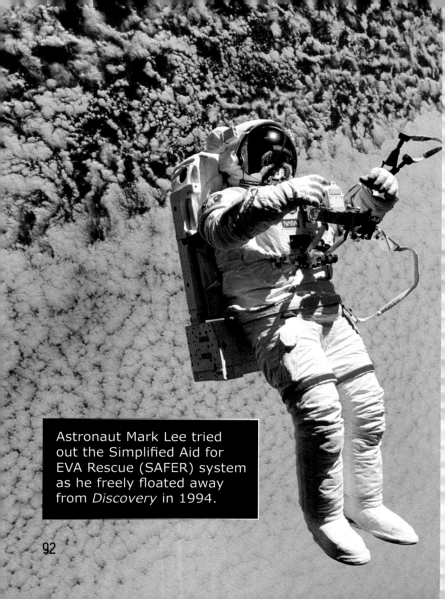

Astronaut Mark Lee tried out the Simplified Aid for EVA Rescue (SAFER) system as he freely floated away from *Discovery* in 1994.

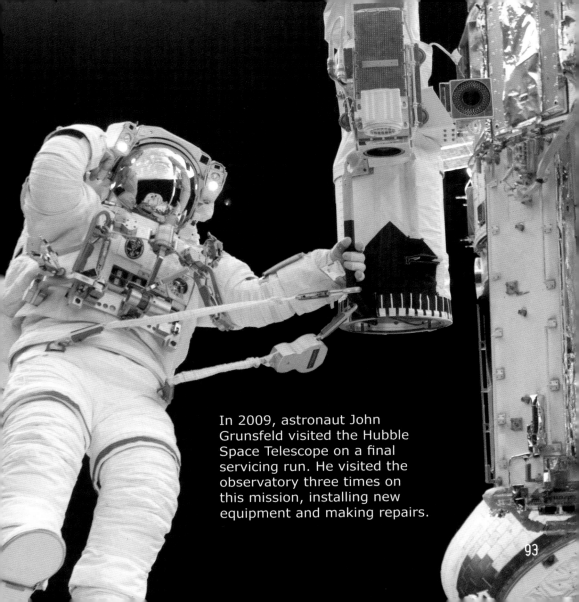

In 2009, astronaut John Grunsfeld visited the Hubble Space Telescope on a final servicing run. He visited the observatory three times on this mission, installing new equipment and making repairs.

The International Space Station

It isn't humanity's first space station but it's definitely the biggest and best. The ISS is a vast outpost in space that stretches the length of a football field and weighs nearly a million pounds. It runs as a cooperative program between the United States, Russia, Canada, Japan, and participating European countries in the European Space Agency (ESA).

Assembly of the ISS began in 1998, and it has been continuously occupied since 2000. It became fully operational in 2009, when it began hosting a rotating crew of six. By the end of 2018, the facility had been visited by well over 200 astronauts and scientists. Crew are typically kept busy with science experiments, maintenance and repairs, and workout regimens (to maintain muscle tone) for over 12 hours a day.

While the research done at the ISS furthers our understanding of life in space, it also has the benefit of improving life on Earth. Experiments with plant

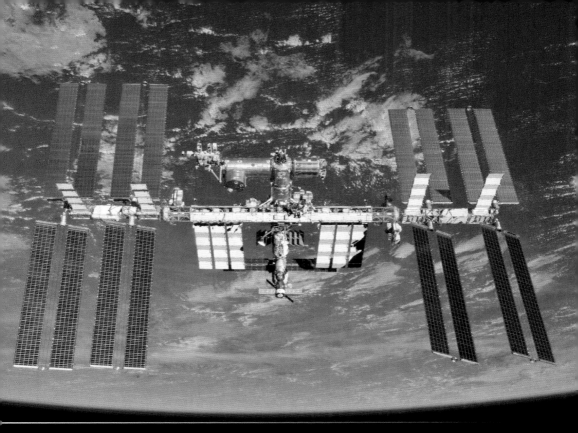

growth in space have helped
scientists anticipate how to feed
astronauts during long-term
missions beyond Earth's orbit.
These experiments have also
helped us learn how to grow

ground. The ISS has facilitated
research in many other
areas, including astronomy,
meteorology, biology,
medicine and pharmaceuticals,
and human research.

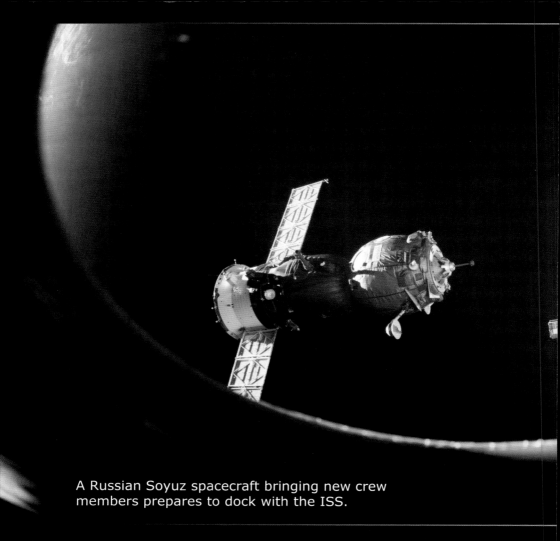

A Russian Soyuz spacecraft bringing new crew members prepares to dock with the ISS.

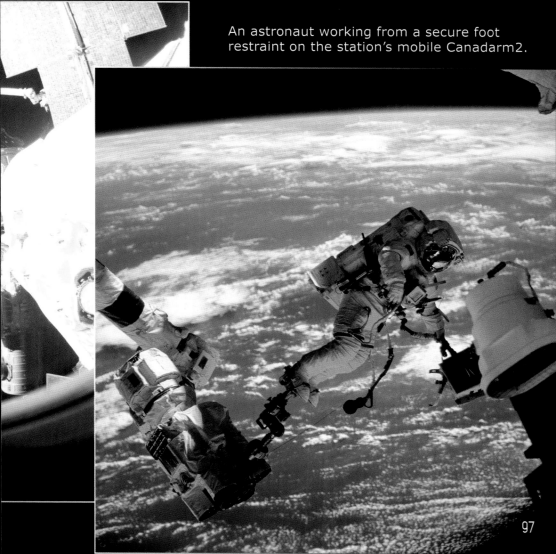

An astronaut working from a secure foot restraint on the station's mobile Canadarm2.

Astronauts made regular construction
spacewalks during early assembly of the
ISS. Here, an astronaut is removing a keel
pin from the truss for long-term stowage.

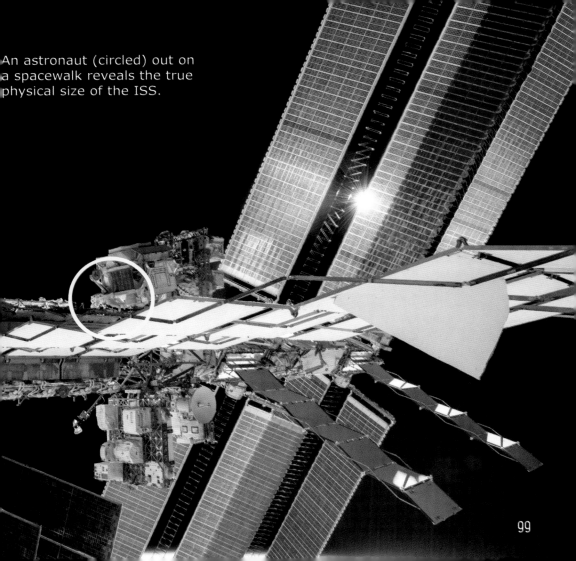

An astronaut (circled) out on a spacewalk reveals the true physical size of the ISS.

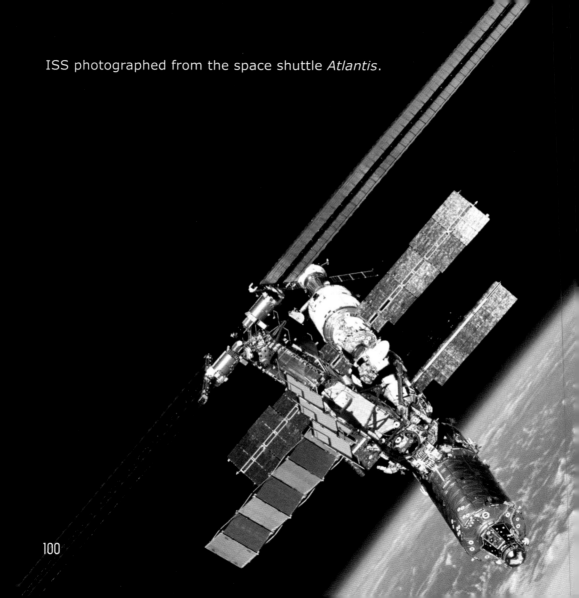

ISS photographed from the space shuttle *Atlantis*.

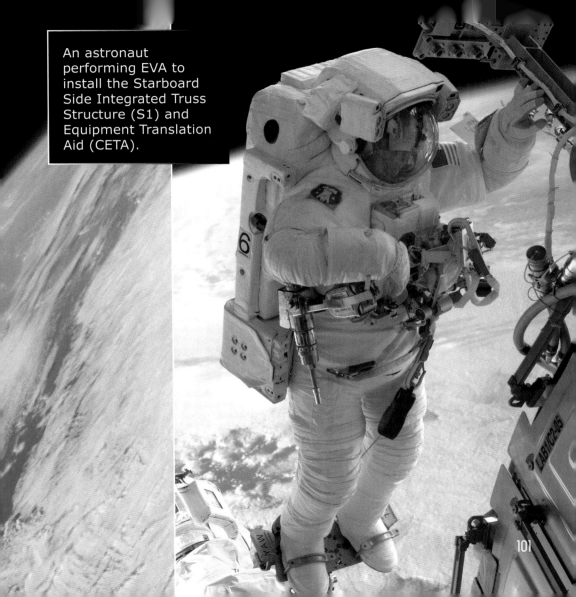

An astronaut performing EVA to install the Starboard Side Integrated Truss Structure (S1) and Equipment Translation Aid (CETA).

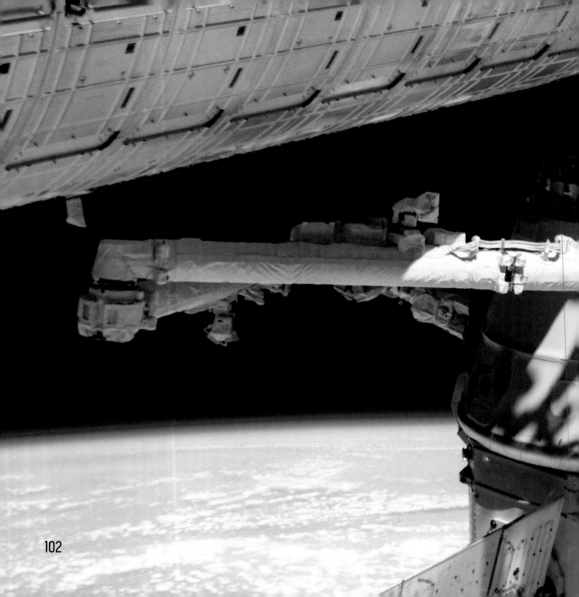

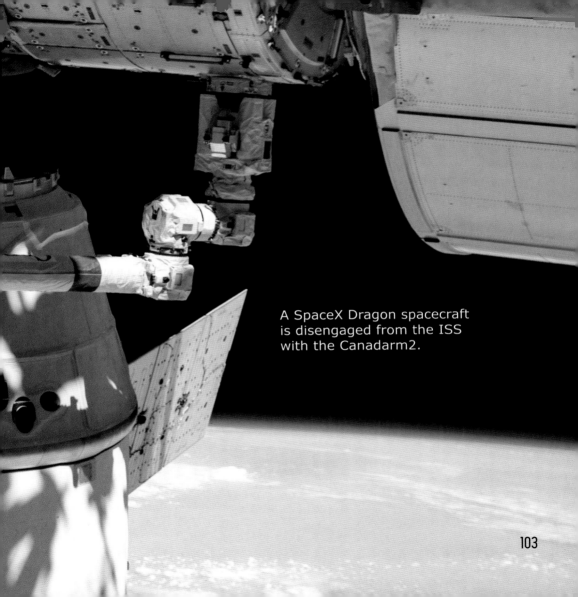

A SpaceX Dragon spacecraft is disengaged from the ISS with the Canadarm2.

The silhouette of the ISS is seen
as it transits the Sun with seven
crew members on board.

The Moon

Our closest celestial neighbor, the Moon, lies less than half a million miles away. At about one quarter of the Earth's size, it has a significant effect on our planet; the two bodies gravitationally interact with one another. Earth's tides are a result of the moon's orbit. Over time, this interaction has caused the Moon to become tidally locked—the same side always faces Earth.

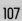

Darker areas, known as *maria* (Latin for "seas"), are the result of ancient lava flows.

Impact craters cover the surface of the Moon. Some, like the Tycho crater, are clearly visible from Earth.

The far side of the Moon does not have the vast maria of the Earth-facing side. Instead, pockmarked highlands predominate. Studies have shown that the Moon's crust is thicker on the far side, making it more difficult for lava to make it to the surface. It's not clear why the Moon's crust has this asymmetry. This mosaic image was composed of images taken between 2009 and 2011 by NASA's Lunar Reconnaissance Orbiter Camera (LROC). The Soviet Luna 3 spacecraft took the first images of the far side in 1959.

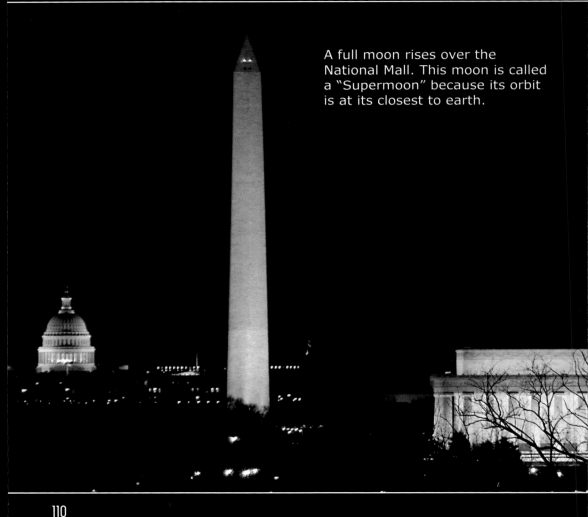

A full moon rises over the National Mall. This moon is called a "Supermoon" because its orbit is at its closest to earth.

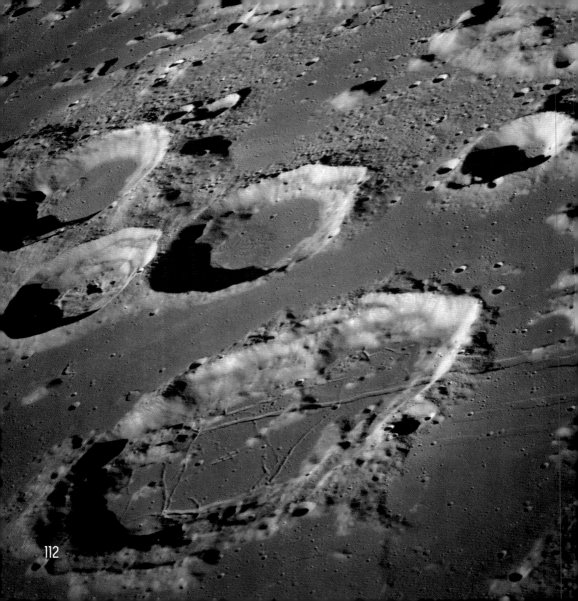

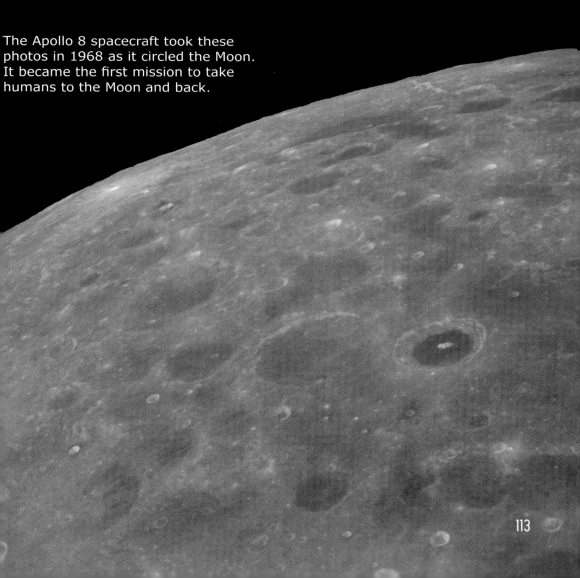

The Apollo 8 spacecraft took these photos in 1968 as it circled the Moon. It became the first mission to take humans to the Moon and back.

113

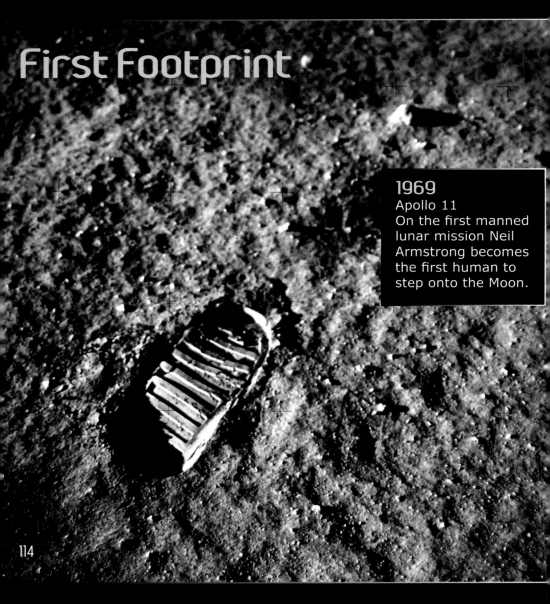

First Footprint

1969
Apollo 11
On the first manned lunar mission Neil Armstrong becomes the first human to step onto the Moon.

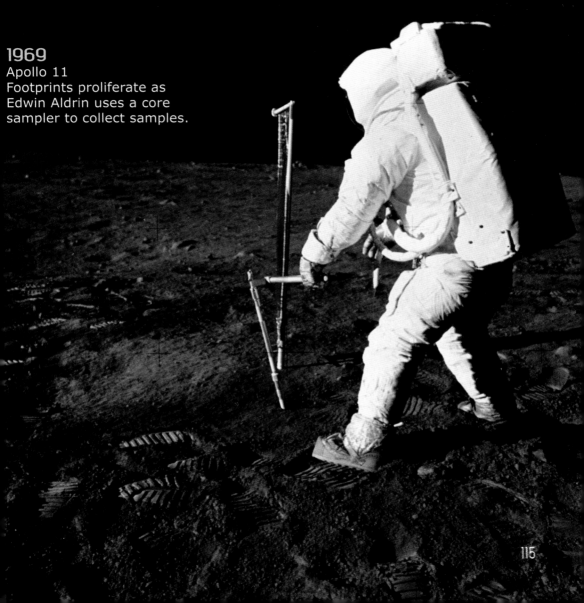

1969
Apollo 11
Footprints proliferate as
Edwin Aldrin uses a core
sampler to collect samples.

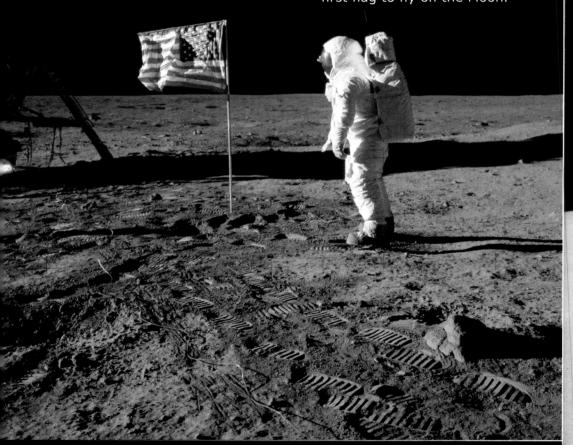

1969
Apollo 11
Edwin Aldrin stands next to the first flag to fly on the Moon.

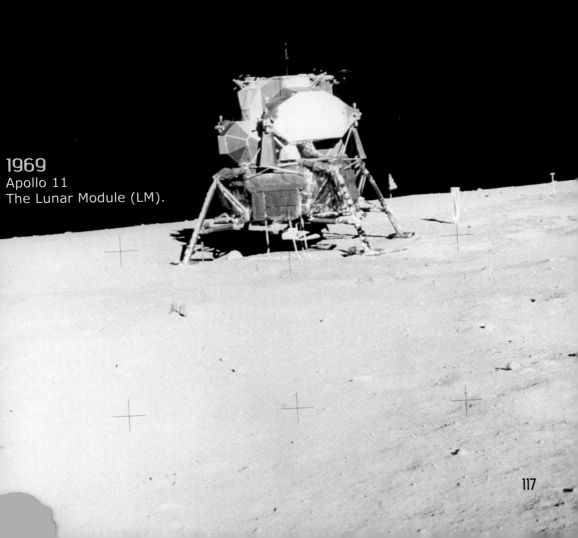

1969
Apollo 11
The Lunar Module (LM).

117

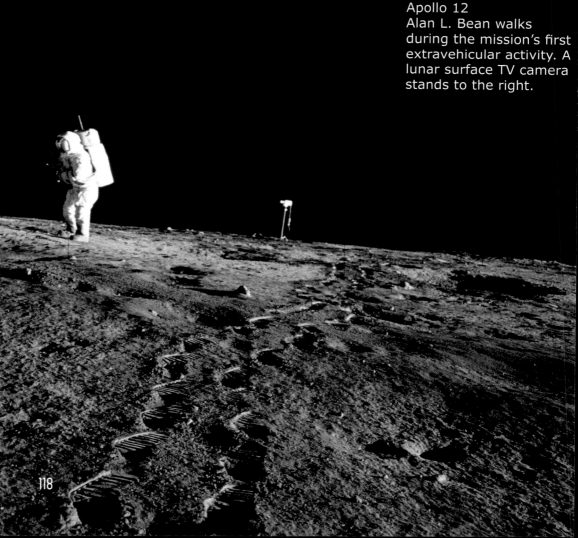

Apollo 12
Alan L. Bean walks during the mission's first extravehicular activity. A lunar surface TV camera stands to the right.

1969
Apollo 12
Charles Conrad Jr. next to Surveyor 3, an unmanned spacecraft that landed on the Moon in 1967. The Lunar Module (LM) stands in the background.

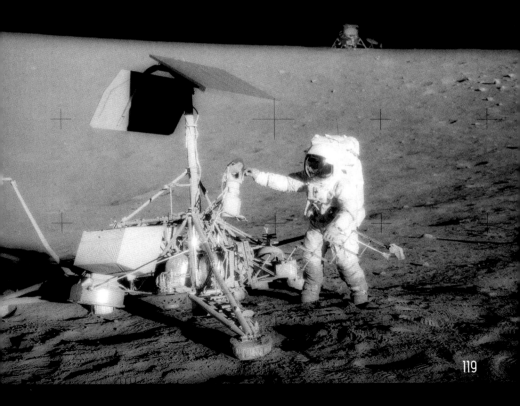

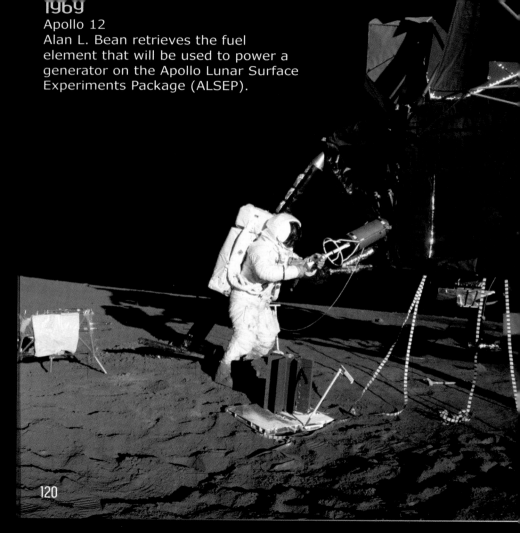

Apollo 12
Alan L. Bean retrieves the fuel
element that will be used to power a
generator on the Apollo Lunar Surface
Experiments Package (ALSEP).

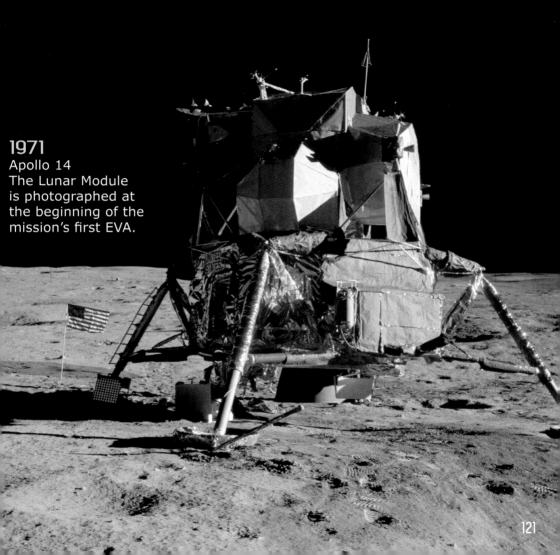

1971
Apollo 14
The Lunar Module
is photographed at
the beginning of the
mission's first EVA.

121

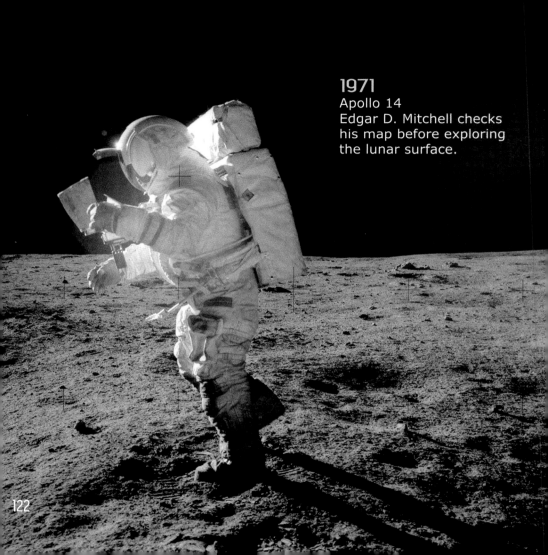

1971
Apollo 14
Edgar D. Mitchell checks
his map before exploring
the lunar surface.

122

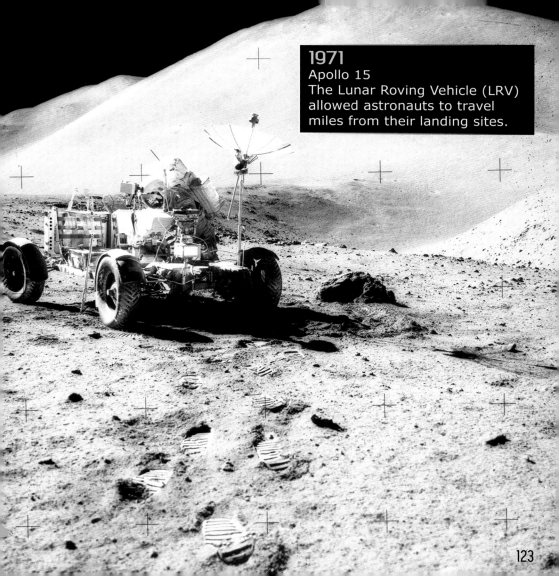

1971
Apollo 15
The Lunar Roving Vehicle (LRV)
allowed astronauts to travel
miles from their landing sites.

123

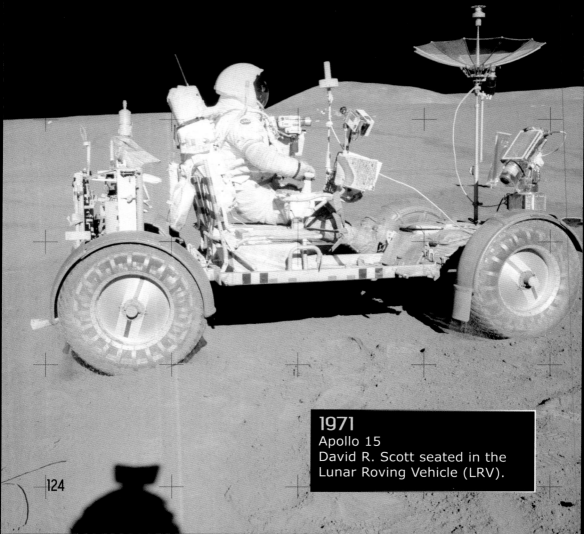

124

1971
Apollo 15
David R. Scott seated in the
Lunar Roving Vehicle (LRV).

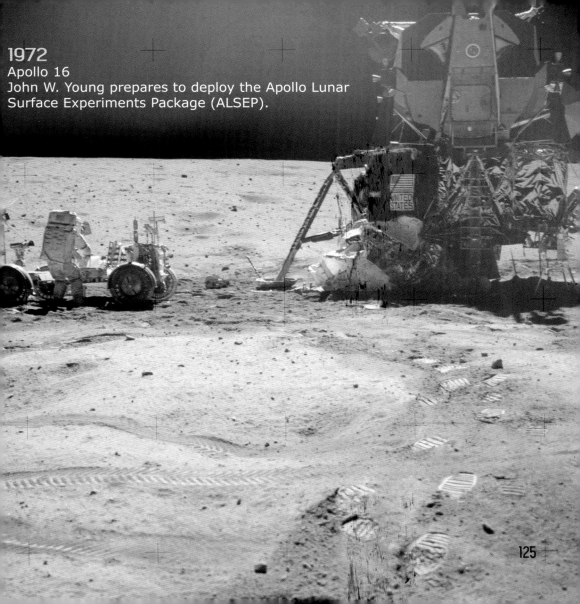

1972
Apollo 16
John W. Young prepares to deploy the Apollo Lunar
Surface Experiments Package (ALSEP).

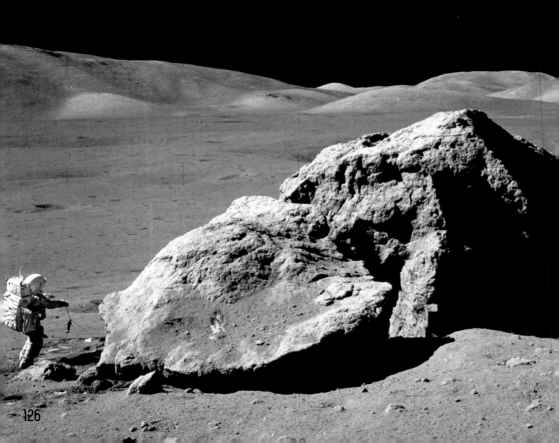

1972
Apollo 17
Harrison H. Schmitt next to
a massive split boulder.

126

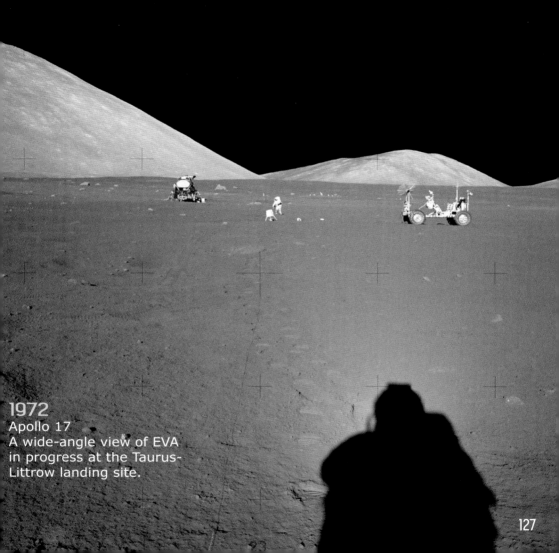

1972
Apollo 17
A wide-angle view of EVA
in progress at the Taurus-
Littrow landing site.

127

Mercury

Smallest of the eight planets, and closest to the Sun, tiny Mercury is a barren world practically devoid of atmosphere and blasted by intense solar radiation. Mercury is nearly tidally locked to the Sun; a single day on the planet is equivalent to about 59 Earth days. Temperatures on the day side can hover near 800 degrees Fahrenheit and plunge to nearly 300 below during the long night. Like the Moon, Mercury's surface is pockmarked with craters. Basins, deep trenches, soaring cliffs, and crater rays crisscross the battered surface. Some of the deep, unlit craters near the poles contain water ice.

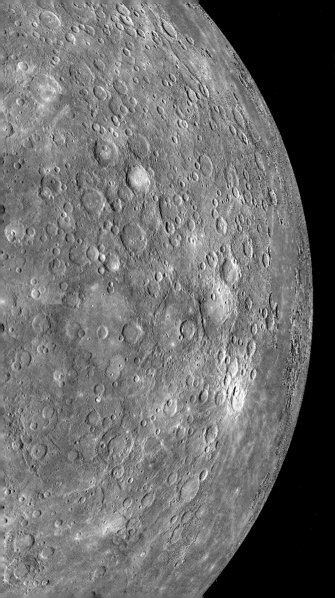

MESSENGER became the second NASA spacecraft to approach Mercury. It sent us this silhouette image in 2008. The first spacecraft to ever orbit Mercury, it gave us information about the planet's magnetic field, proved the existence of ice at the north pole, and gave us beautiful new close-ups of the surface.

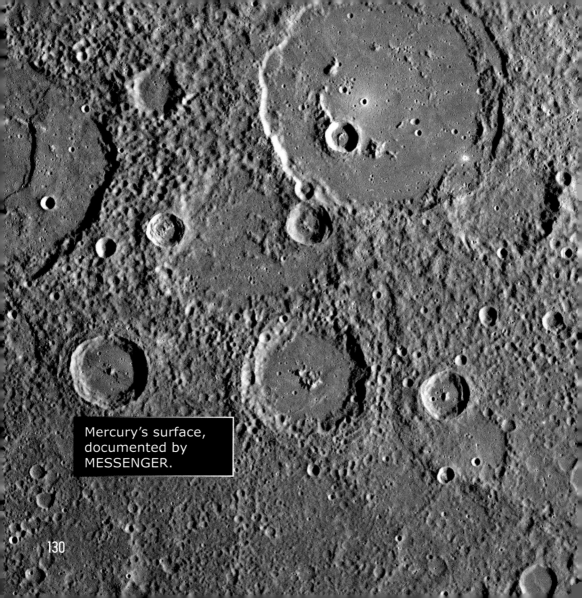

Mercury's surface, documented by MESSENGER.

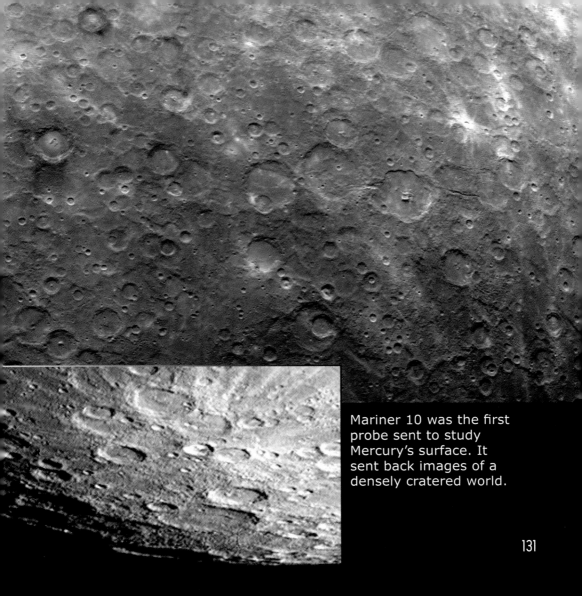

Mariner 10 was the first probe sent to study Mercury's surface. It sent back images of a densely cratered world.

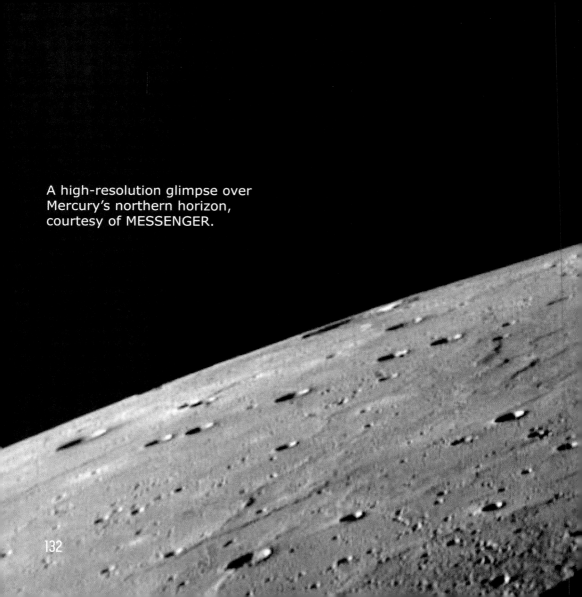

A high-resolution glimpse over Mercury's northern horizon, courtesy of MESSENGER.

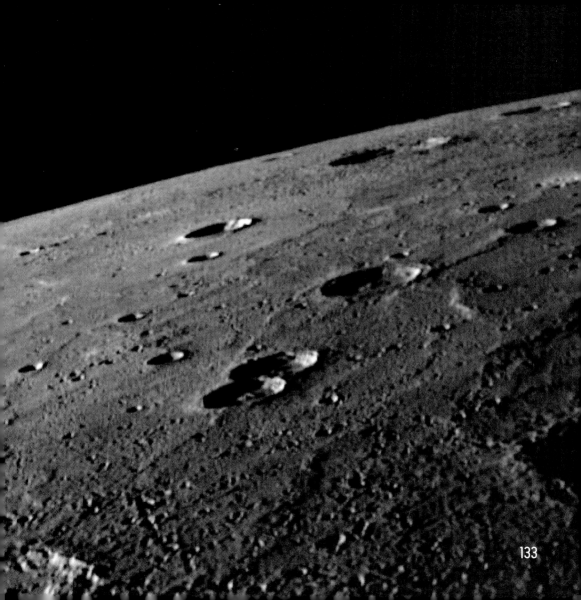

133

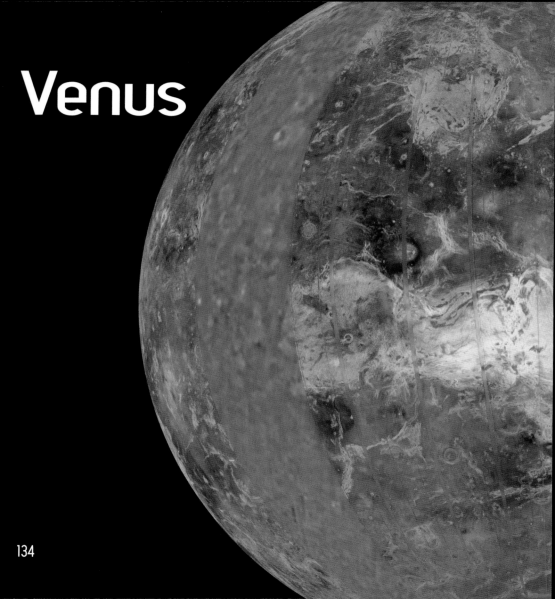

Venus

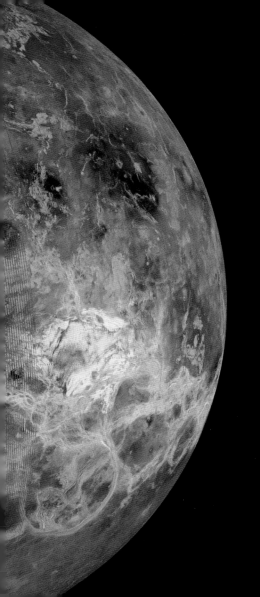

Venus is the second-closest planet to the Earth and easily seen by the naked eye. The beautiful point of light we call both "morning star" and "evening star" may seem like a jewel in the twilight sky, but Venus is actually a hellishly hot place. Venus's atmospheric pressure at the surface is so intense that it would feel like being over a mile beneath the ocean to us. Because of the combination of heat and pressure, the few Russian spacecraft that landed on its surface were quickly melted and crushed. The toxic atmosphere is hot enough to melt lead.

We know a little about Venus's topography thanks to radar mapping that has been done at a safe distance. The Magellan mission (1989–1994) gave us some of the most detailed information about the surface of this seething world.

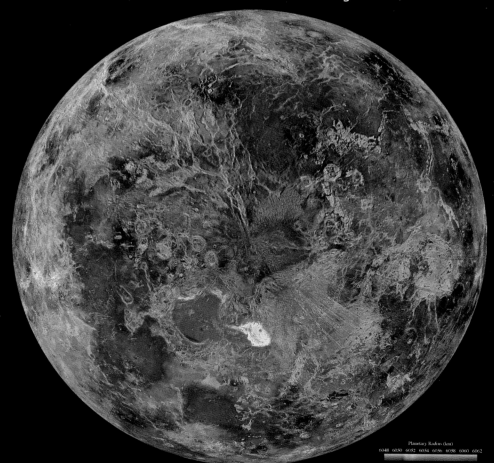

Planetary Radius (km)

6048 6050 6052 6054 6056 6058 6060 6062

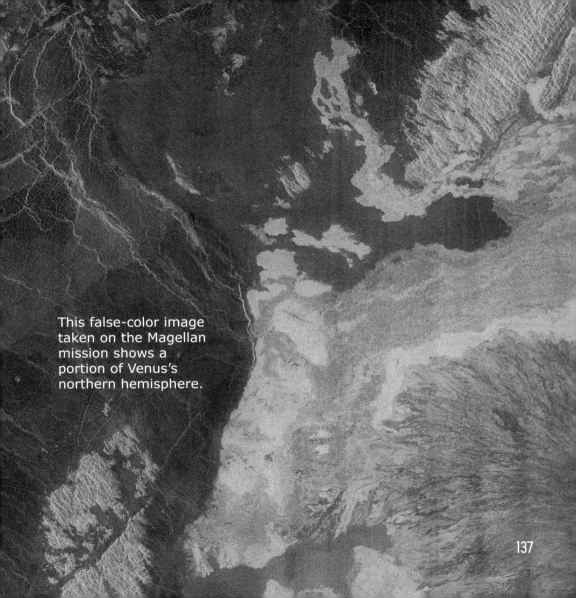

This false-color image taken on the Magellan mission shows a portion of Venus's northern hemisphere.

NASA's Solar Dynamics Observatory (SDO) captured this image of Venus making a transit across the face of the Sun in 2012. Venus is about 0.7 times Earth's distance from the Sun.

Mars

No other planet in our solar system has caused as much speculation as the faint red dot that wanders our night sky. As a nearby neighbor of the Earth, it is regularly visible from the ground, and uniquely red in appearance. It's only about half the size of our planet, but its surface boasts some of the most spectacular scenery in the solar system. The Valles Marineris canyon is four times longer and six times deeper than the Grand Canyon in Arizona. The shield volcano Olympus Mons is about the size of New Mexico. Vast regions of the planet can be covered in immense dust storms that obscure the surface from observation for weeks at a time.

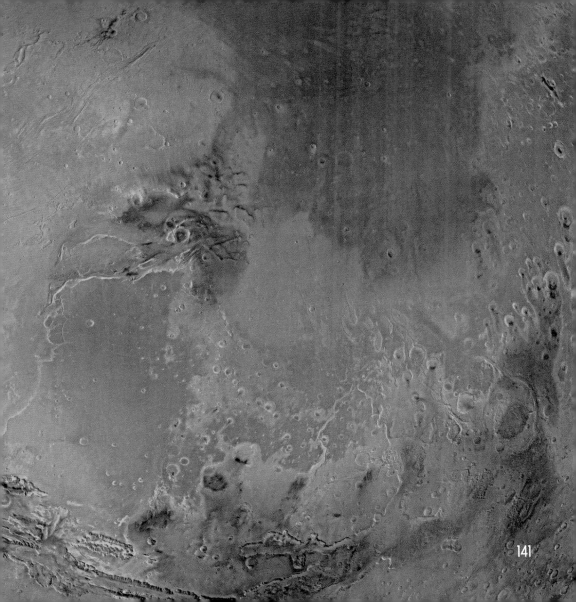

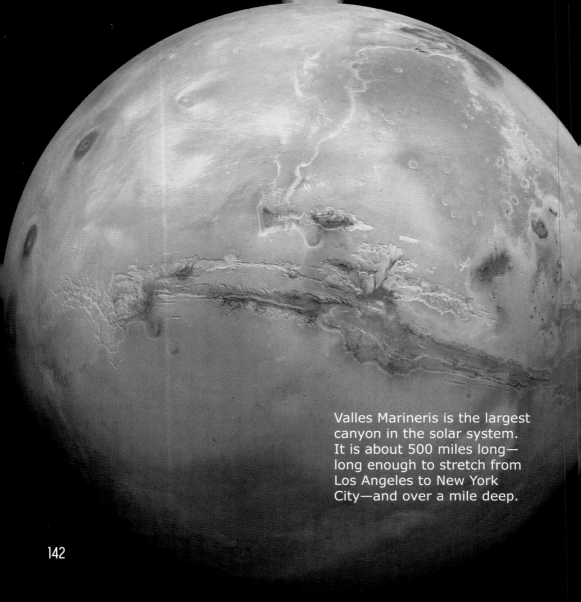

Valles Marineris is the largest canyon in the solar system. It is about 500 miles long—long enough to stretch from Los Angeles to New York City—and over a mile deep.

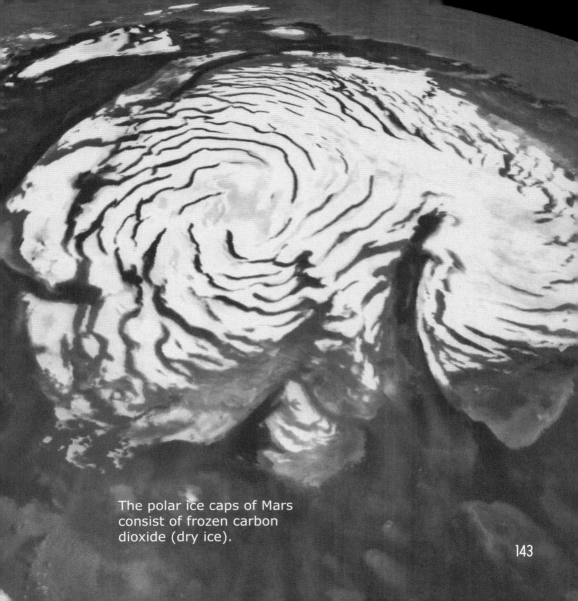

The polar ice caps of Mars consist of frozen carbon dioxide (dry ice).

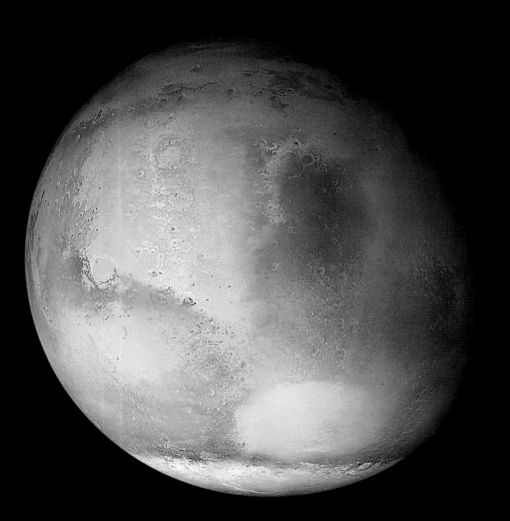

Dust storms can cover the entire planet. The image on the
right was taken one month after the image on the left.

From the Ground

Multiple missions have attempted to reach the surface of the Red Planet. Many have failed. The very first successful landing occurred in 1971, when a Russian lander touched down and managed to transmit 20 seconds of data before malfunctioning. The first successful American lander, Viking 1, touched down in 1976. In the six years this mission lasted, it studied the surface and took soil samples. Numerous Russian and American missions ensued, followed by attempts by Japan, the ESA, India, and China.

Decades after the Viking landers of the 1970s, more sophisticated exploration vehicles began arriving on the surface. The first roving robotic vehicle—NASA's Sojourner—touched down in 1997. The Spirit and Opportunity rovers followed in 2004. The Curiosity rover arrived in 2012. Most recently, the Perseverance rover and Ingenuity helicopter—a helicopter built specifically to test the first powered flight on another planet—arrived on Mars in early 2021.

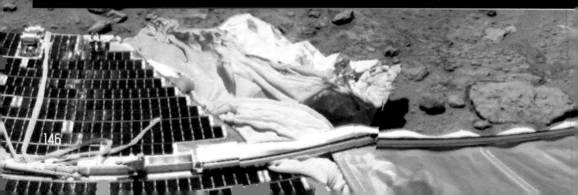

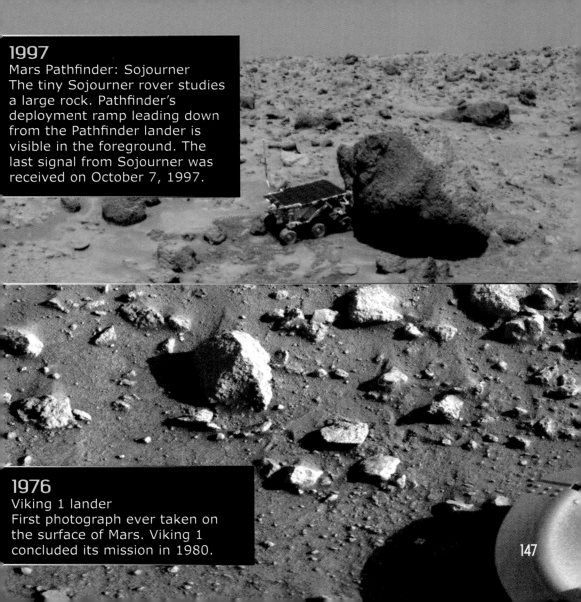

1997
Mars Pathfinder: Sojourner
The tiny Sojourner rover studies a large rock. Pathfinder's deployment ramp leading down from the Pathfinder lander is visible in the foreground. The last signal from Sojourner was received on October 7, 1997.

1976
Viking 1 lander
First photograph ever taken on the surface of Mars. Viking 1 concluded its mission in 1980.

147

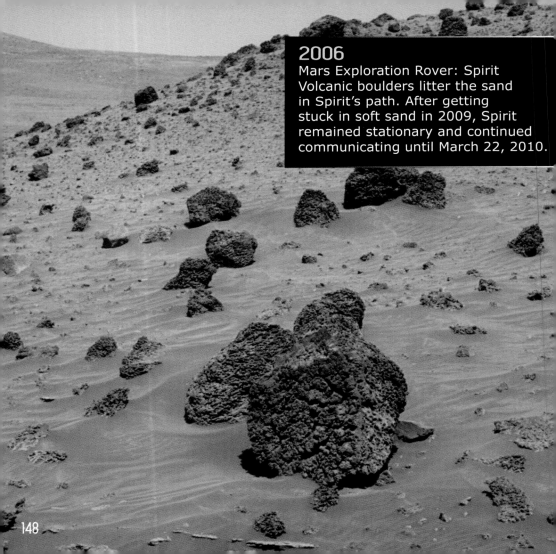

2006
Mars Exploration Rover: Spirit
Volcanic boulders litter the sand
in Spirit's path. After getting
stuck in soft sand in 2009, Spirit
remained stationary and continued
communicating until March 22, 2010.

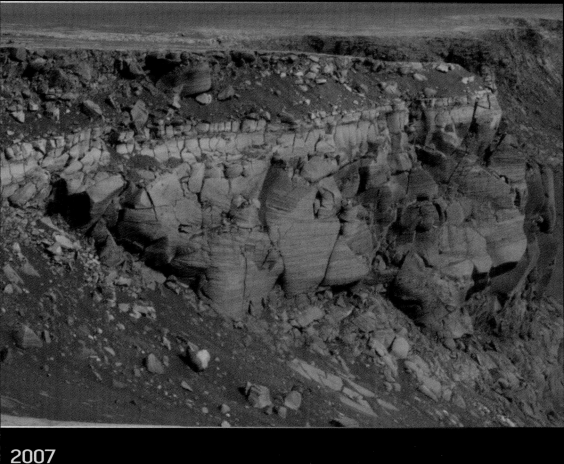

2007
Mars Exploration Rover: Opportunity
Opportunity stands at the lip of Victoria Crater before heading
down. Due to the large planetary 2018 dust storm on Mars,
Opportunity stopped communicating on June 10, 2018.

This illustration depicts NASA's Mars 2020 spacecraft approaching Mars. The spacecraft kept Perseverance safe on its seven-month journey to the Red Planet.

2020

Mars Exploration Rover: Perseverance
NASA launched the Perseverance
rover in July 2020. Its main job is
to collect rock and soil samples for
possible return to Earth. Perseverance
landed on Mars on February 18, 2021.

Perseverance took this image in
2021, after drilling two holes in
the pictured rock (nicknamed
"Rochette") in search of samples.

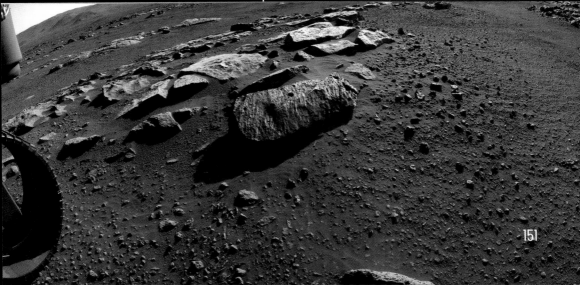

Mars helicopter: Ingenuity

After hitching a ride attached to the belly of Perseverance, Ingenuity landed safely on Mars along with the rover. In April of 2021, Ingenuity made its inaugural flight, hovering for a total of 39.1 seconds.

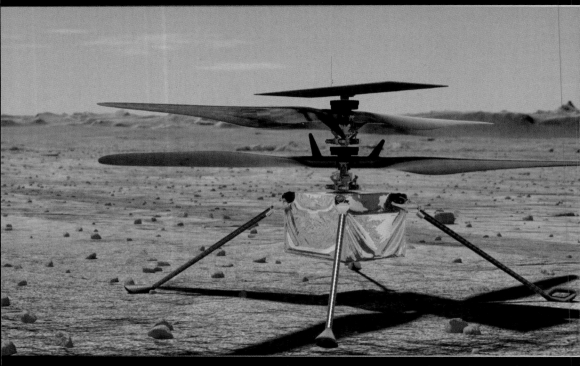

This image is an artist's rendition of the Ingenuity helicopter on the surface of Mars.

The second color image taken by Ingenuity, taken from a height of about 17 feet (5.2 meters). Tracks made by Perseverance are visible across the surface of the planet.

153

A Ring of Rocks

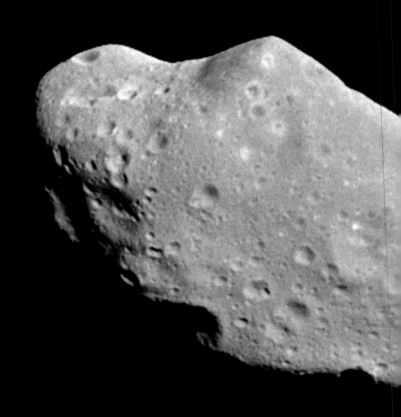

Some of the most interesting objects in our solar system are the smallest. The asteroid belt is a wide, diffuse circle of small rocky bodies orbiting the Sun between Mars and Jupiter. This band of asteroids may have begun as a number of larger objects that were broken apart in a collision with another planet early in our solar system's history, or it could be material left over from when the solar system was formed. There are also other asteroid groups in the inner solar system.

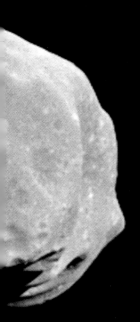

Ida is only 35 miles long, but it has its very own "moon," a tiny satellite named Dactyl.

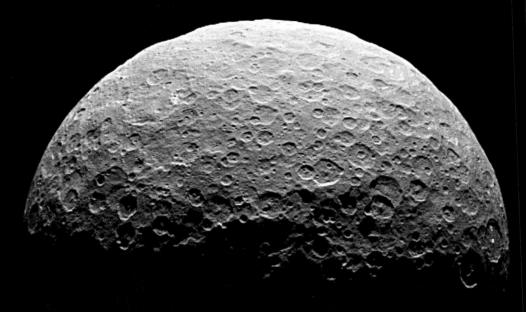

NASA's Dawn spacecraft zoomed in on Ceres in 2015. With a radius of 294 miles, Ceres is the largest object in the asteroid belt. It was reclassified as a dwarf planet in 2006. Unlike most of the other objects in the asteroid belt, Ceres is spherical.

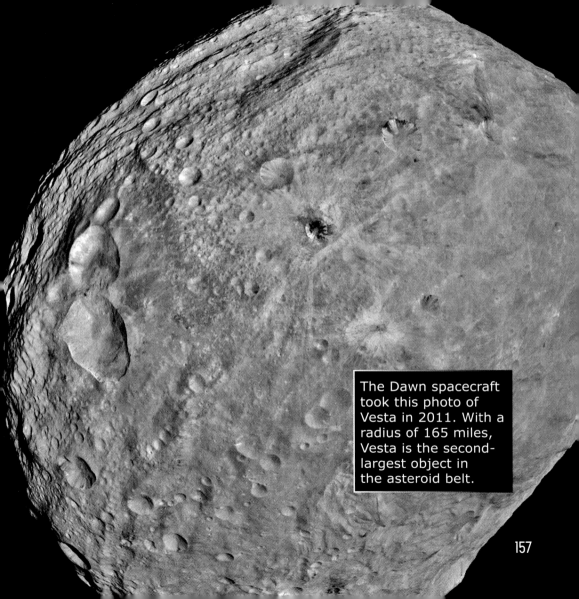

The Dawn spacecraft took this photo of Vesta in 2011. With a radius of 165 miles, Vesta is the second-largest object in the asteroid belt.

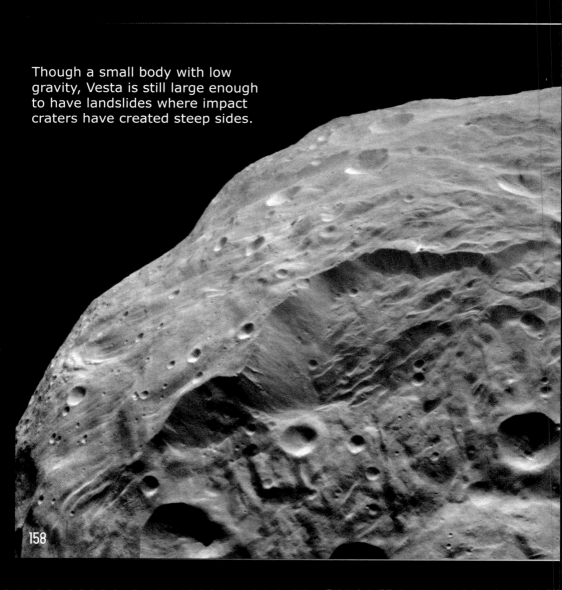

Though a small body with low gravity, Vesta is still large enough to have landslides where impact craters have created steep sides.

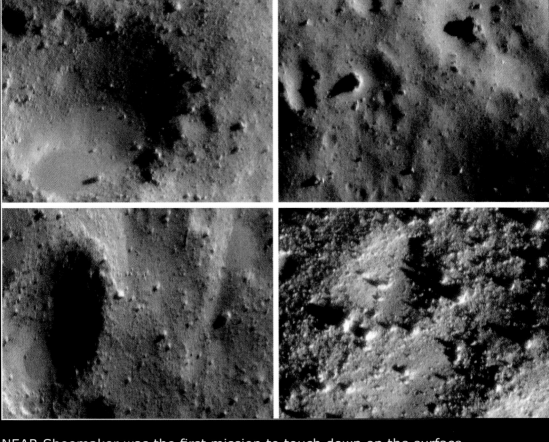

NEAR Shoemaker was the first mission to touch down on the surface of an asteroid. It made contact with the Eros asteroid in 2001.

Jupiter

Jupiter is the largest planet in the solar system and is more than twice as massive as the rest of the planets combined. Seen from space, the planet's great swirling bands of orange, cream, and brown seem like serenely vibrant tapestries. But these beautiful bands and ripples are anything but serene. Jupiter is an incredibly turbulent planet, with surface winds constantly blowing at several hundred miles per hour. Violent storms can form within hours and grow to thousands of miles in size in a single day.

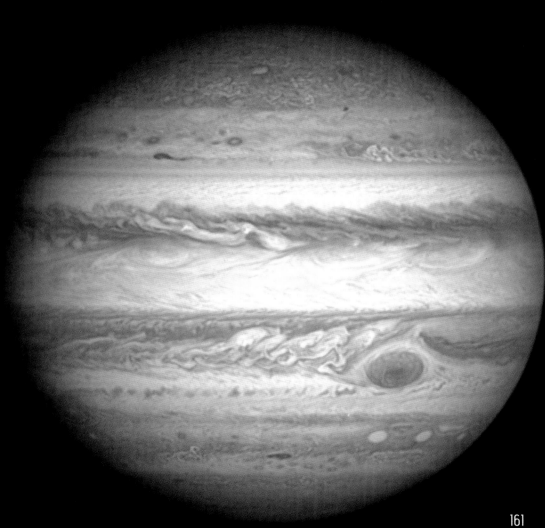

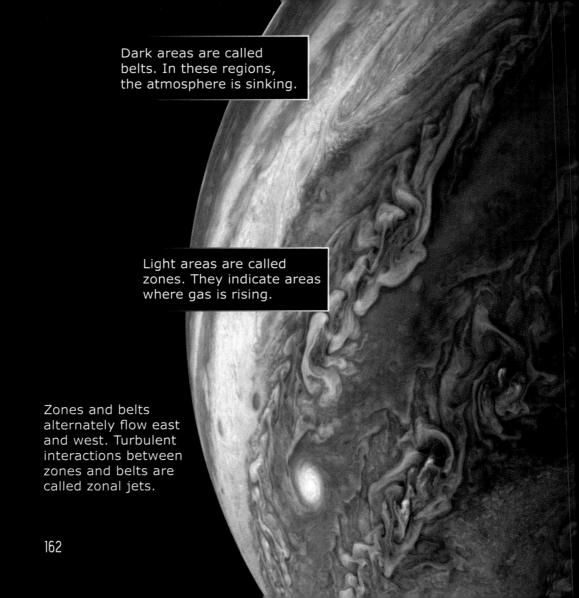

Dark areas are called belts. In these regions, the atmosphere is sinking.

Light areas are called zones. They indicate areas where gas is rising.

Zones and belts alternately flow east and west. Turbulent interactions between zones and belts are called zonal jets.

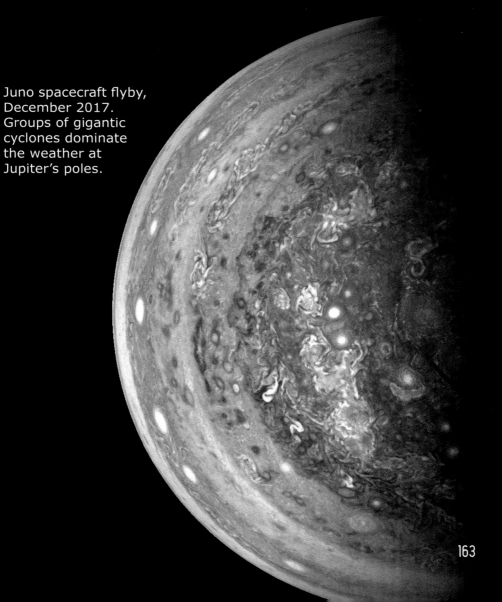

Juno spacecraft flyby,
December 2017.
Groups of gigantic
cyclones dominate
the weather at
Jupiter's poles.

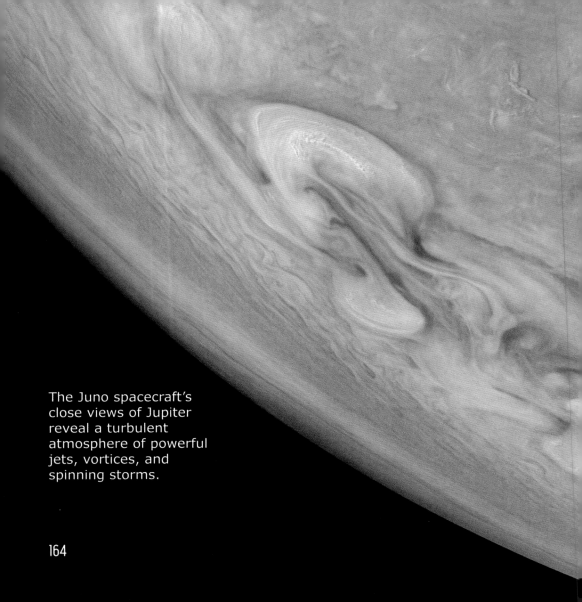

The Juno spacecraft's close views of Jupiter reveal a turbulent atmosphere of powerful jets, vortices, and spinning storms.

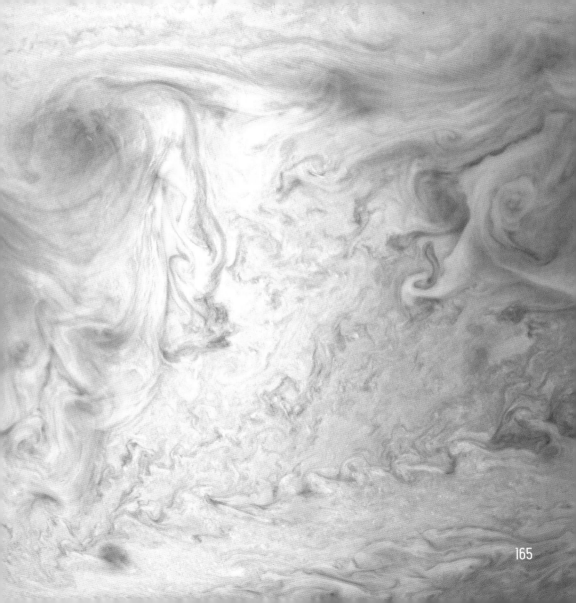

165

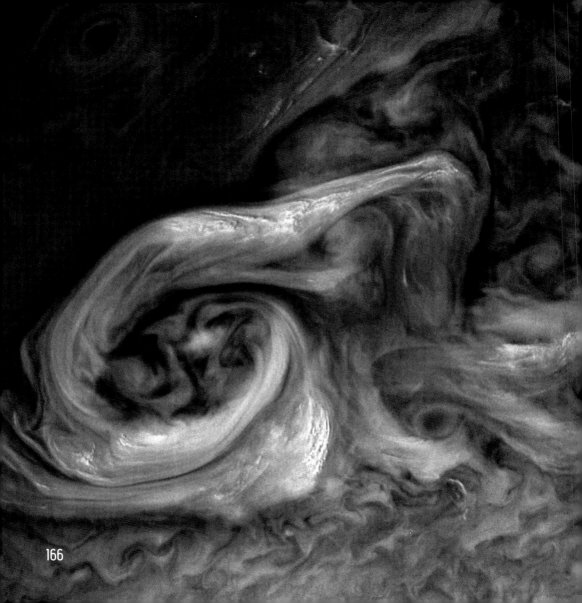

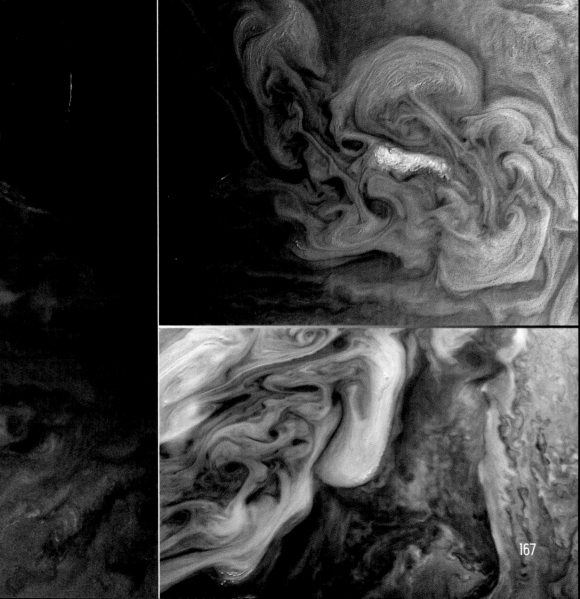

167

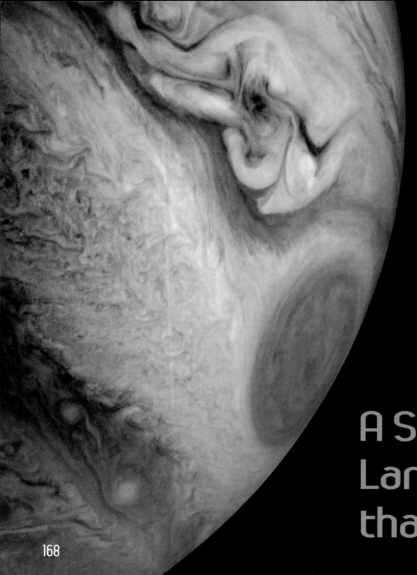

Juno captured this image of Jupiter's southern hemisphere and its Great Red Spot in 2020.

A Storm Larger than Earth

What is it? What caused it? Jupiter's Great Red Spot has vexed astronomers since it was first definitively observed more than a century ago. Its age is uncertain (it may be several centuries old), and while it has shrunk in recent decades, estimates of its lifespan are still up for debate. It is the largest known storm in the solar system. In meteorological terms, it is an anticyclonic circulation system over 10,000 miles wide. It makes a full rotation in about six days. Winds within the system can exceed 400 miles per hour. Data from NASA's Juno spacecraft indicate that the storm has roots extending 200 miles down into Jupiter's atmosphere.

Another unsolved mystery: why is it red in the first place? Scientists have theorized that the concentrated presence of sulfur and phosphorus in the chemical makeup of the storm contributes to the color. Others speculate that churned up chemicals being broken down by sunlight may be the explanation. It's possible that the sheer altitude of the storm may expose it to ultraviolet light from the sun, leading to a photochemical reaction.

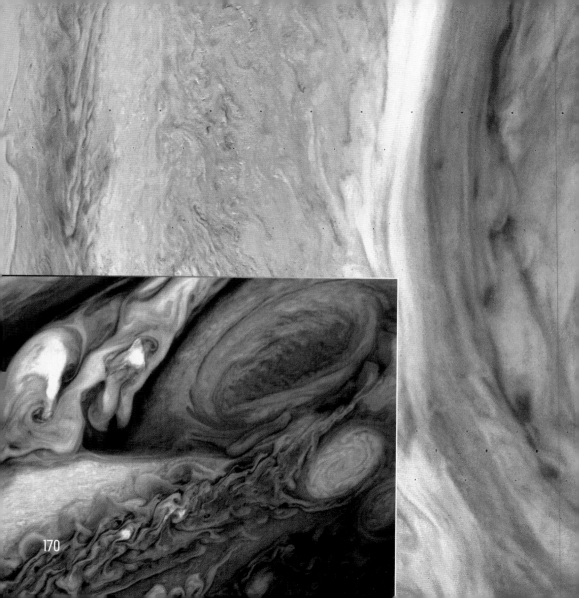

170

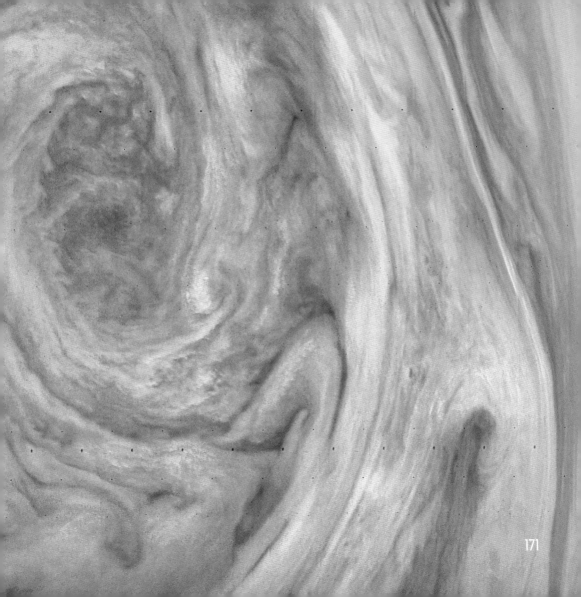

Jupiter's Many Moons

Amalthea casts a
lopsided shadow on the
cloud tops of Jupiter.

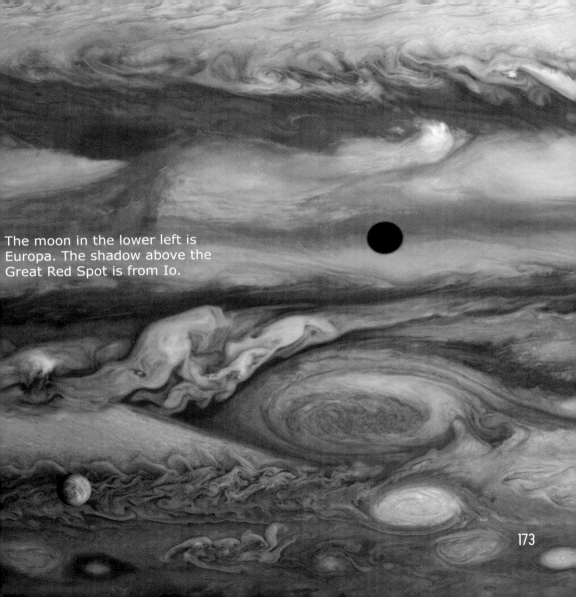

The moon in the lower left is Europa. The shadow above the Great Red Spot is from Io.

173

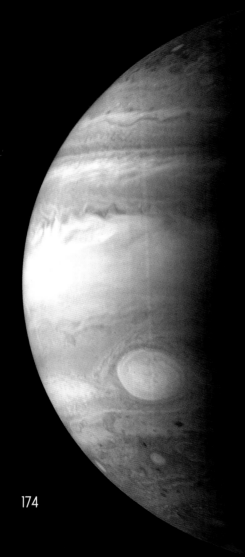

The Galilean Moons

Galileo Galilei is credited with the discovery of the first four moons orbiting a planet other than our own. His improvements to the telescope allowed him to observe them for the first time in 1610. The Galilean moons are Io, Europa, Ganymede, and Callisto.

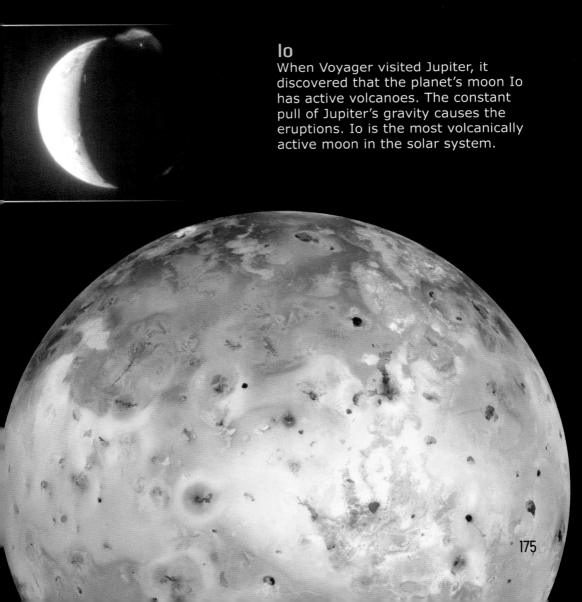

Io

When Voyager visited Jupiter, it discovered that the planet's moon Io has active volcanoes. The constant pull of Jupiter's gravity causes the eruptions. Io is the most volcanically active moon in the solar system.

175

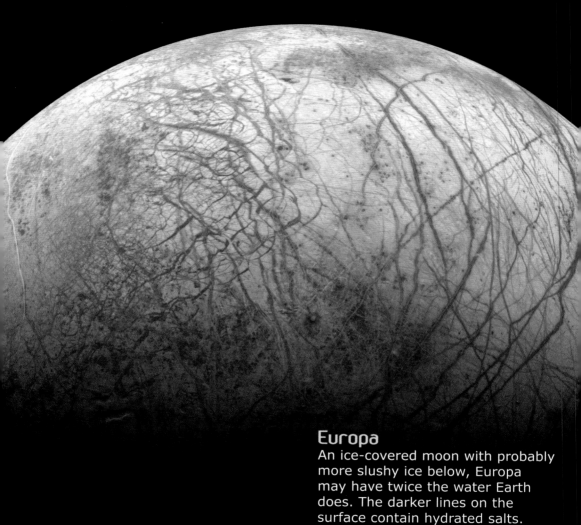

Europa

An ice-covered moon with probably more slushy ice below, Europa may have twice the water Earth does. The darker lines on the surface contain hydrated salts.

Craters like this one are rare on Europa. The moon has a young surface that may be no more than 90 million years old.

Ganymede

The largest moon in the solar system is also the only one to have its own magnetic field. Ganymede's pocked surface is composed mostly of ice. The darker areas are older and more heavily cratered.

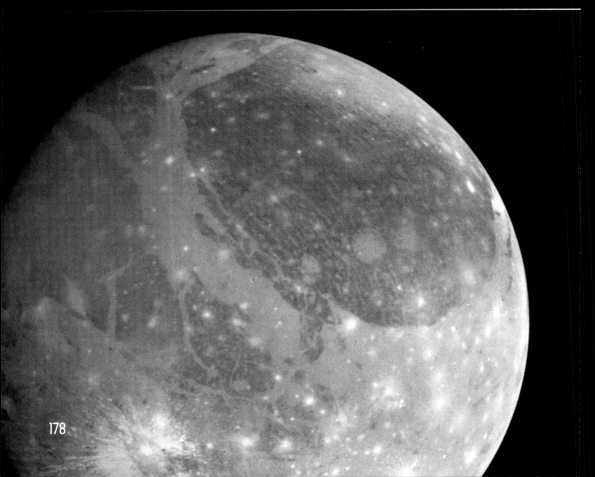

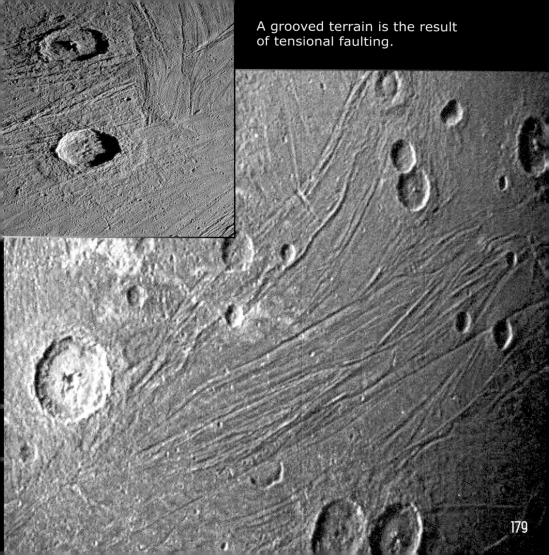

A grooved terrain is the result of tensional faulting.

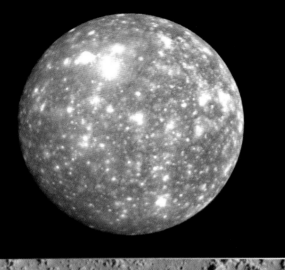

Callisto

Callisto's ancient, cratered face reveals a record of bombardment that goes back to the early history of the solar system. In fact, it may have the oldest landscape in our solar system.

In 2000, Cassini-Huygens snapped this photo of Callisto (bottom left) and Europa (top right) in near perfect alignment.

180

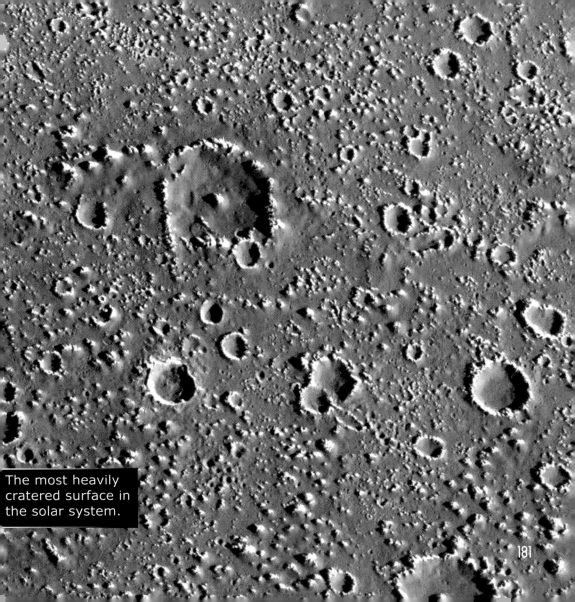

The most heavily cratered surface in the solar system.

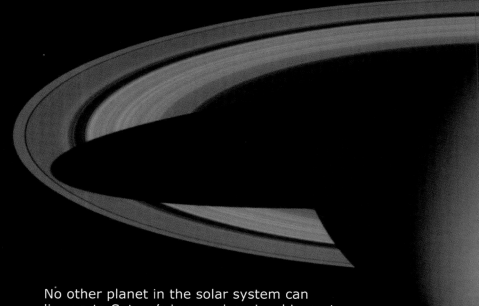

Saturn

No other planet in the solar system can live up to Saturn's impressive visual impact. Each mission to the planet has sent back stunning images. This image was taken by NASA's Cassini spacecraft in 2004 as it approached the planet for orbital insertion.

The gas giant Saturn is the second-largest planet in the solar system and similar in some ways to Jupiter. Its outer atmosphere is banded, it has a vast system of moons (82 as of 2021, with 53 given official names), it rotates rapidly, and its composition is mainly hydrogen and helium.

It is the least dense of all the planets. Saturn does experience violent storms like Jupiter, but they are visually muted when seen from space. These storms may appear as pale white ovals.

Missions
to Saturn

Pioneer 11 flyby: 1979
Voyager 1 flyby: 1980
Voyager 2 flyby: 1981
Cassini-Huygens orbiter: 2004
Huygens probe (landing on Titan): 2004

A massive storm
kicks up mysterious
white clouds in the
planet's northern
hemisphere. Saturn's
banded atmosphere
develops jets and
vortices that appear
similar to Jupiter's.

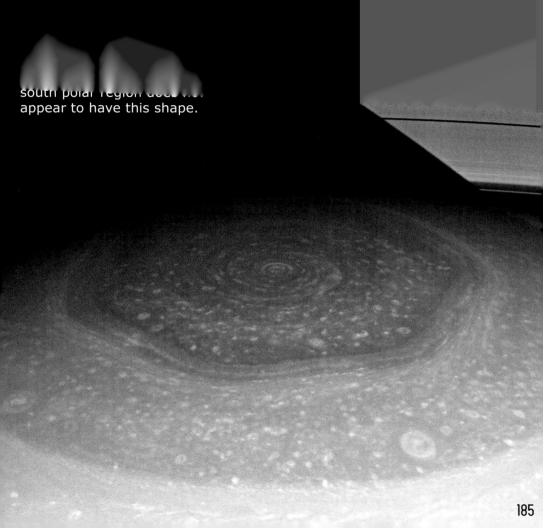

south polar region does not appear to have this shape.

185

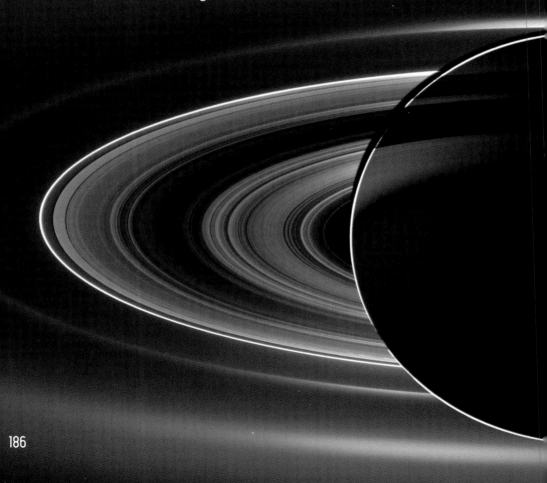

Cassini took this image of Saturn backlit by the sun in 2013. The unique perspective allowed scientists to see new details in the rings.

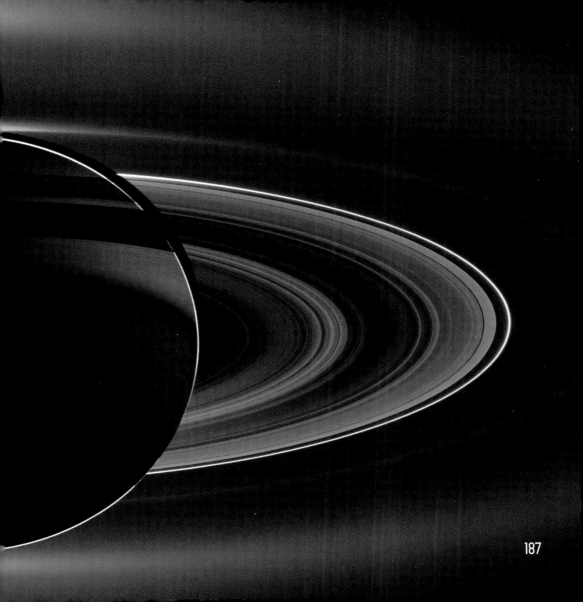

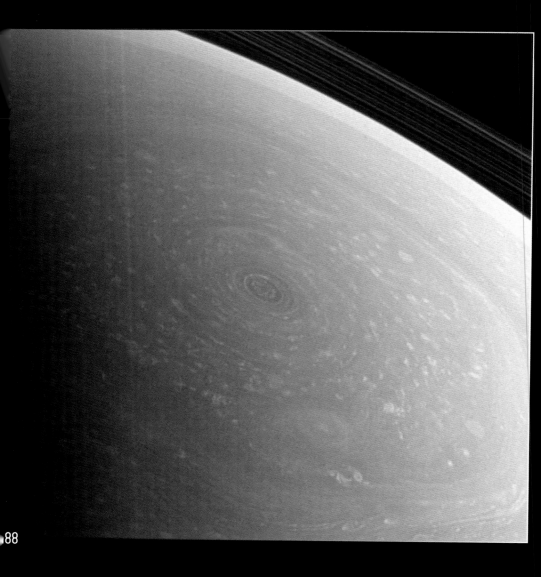

88

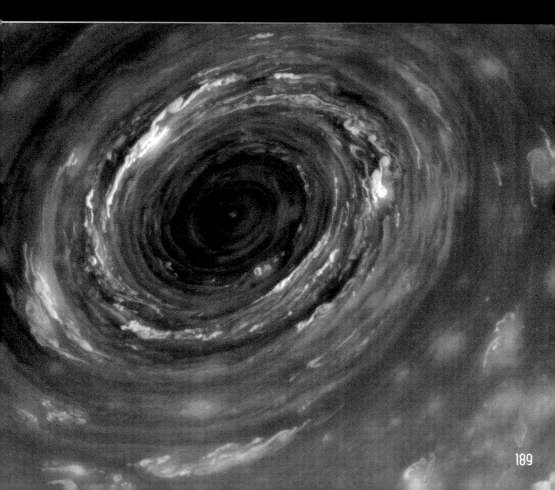

189

Lord of the Rings

When Galileo turned his new telescope toward Saturn in 1610, he was surprised to discover that it did not appear perfectly spherical. Western astronomers had always assumed that all heavenly bodies were symmetrical in shape. But there was something very strange about this object, when magnified. It seemed to be three objects lumped together. Over time, the two end objects faded. Then they came back. Galileo had discovered Saturn's rings. Because the rings are slim and because Saturn is tilted on its axis like Earth, one or more times every 15 years the rings actually disappear from our view for a short time. This event is known as ring plane crossing.

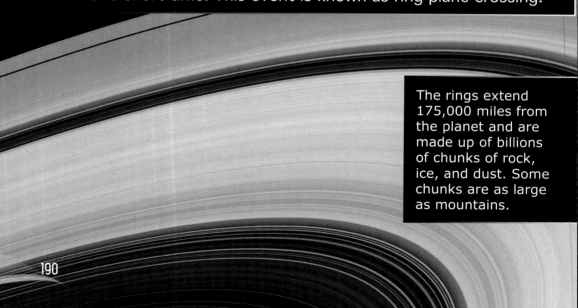

The rings extend 175,000 miles from the planet and are made up of billions of chunks of rock, ice, and dust. Some chunks are as large as mountains.

Saturn's rings are typically divided into lettered groups.
Groups are separated by gaps called divisions.

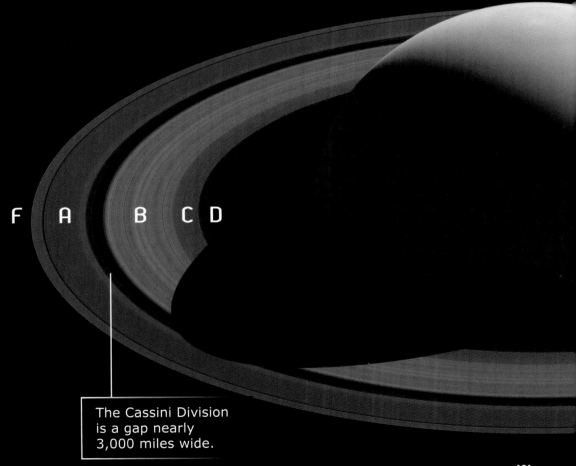

F A B C D

The Cassini Division
is a gap nearly
3,000 miles wide.

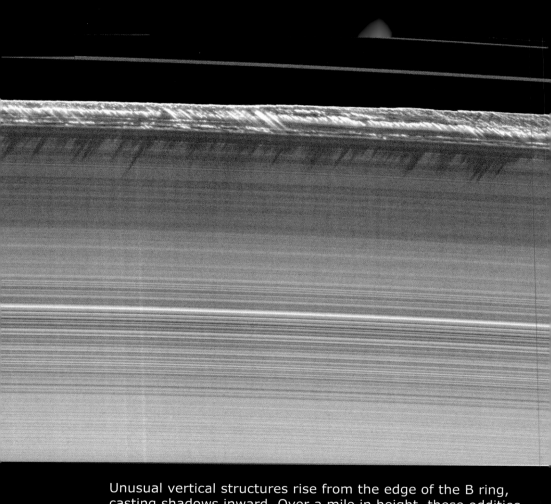

Unusual vertical structures rise from the edge of the B ring, casting shadows inward. Over a mile in height, these oddities in the ring's plane may be the result of disruption due to the pull of moonlets and other large objects orbiting

Looking up toward
the equator, the ring
shadow can just be
seen at the edge
of Saturn's face.

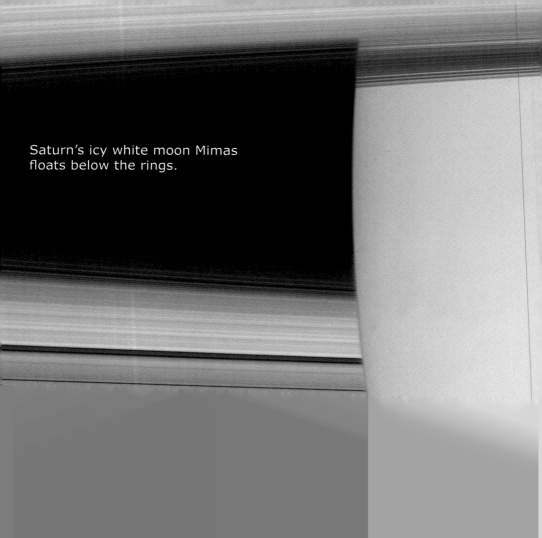
Saturn's icy white moon Mimas floats below the rings.

Saturn's rings may have a single origin or several. It has been theorized that they are the natural by-products of the planetary formation process. Passing space debris like icy comets and asteroids may have been captured in Saturn's orbit. It has also been suggested that one or more moons broke up in an unstable orbit around the planet. In this image, the planet has been deliberately removed to show the rings alone.

Saturn's Moons

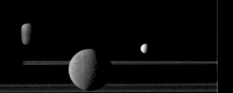

The Cassini spacecraft captured this image of three of Saturn's moons in 2011. Rhea is in the center, Dione is to the left (partially blocked by the dark horizon of Saturn), and Enceladus is to the right.

Cassini got a close look at Enceladus when it passed within 15 miles of the moon's surface in 2008.

Battered Iapetus, seen by Cassini in 2007. The dark material covering the right hemisphere may be a form of carbon.

197

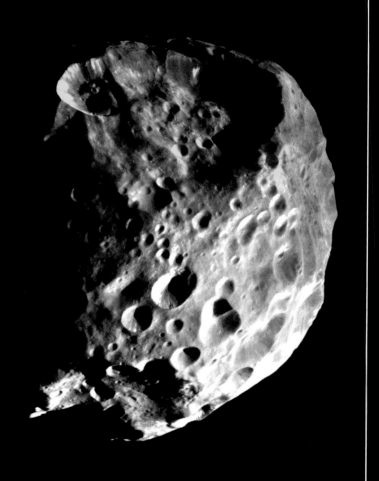

Cassini's flyby
in 2004 showed
Phoebe to be a
rough-looking icy
rock. Astronomers
speculate that it
may have originated
in the Kuiper belt.

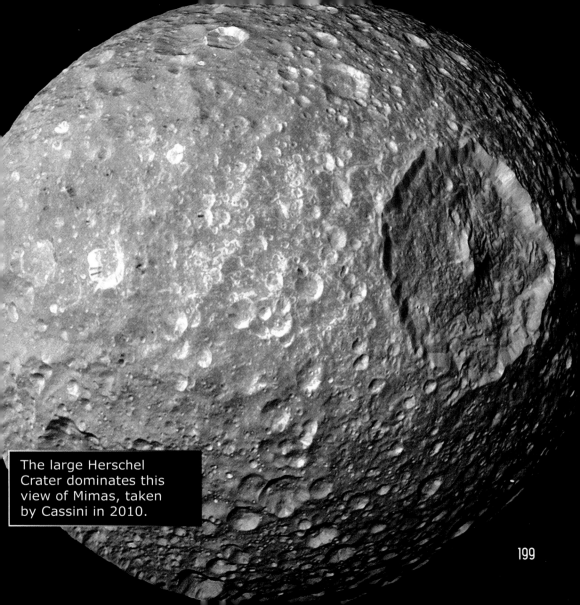

The large Herschel Crater dominates this view of Mimas, taken by Cassini in 2010.

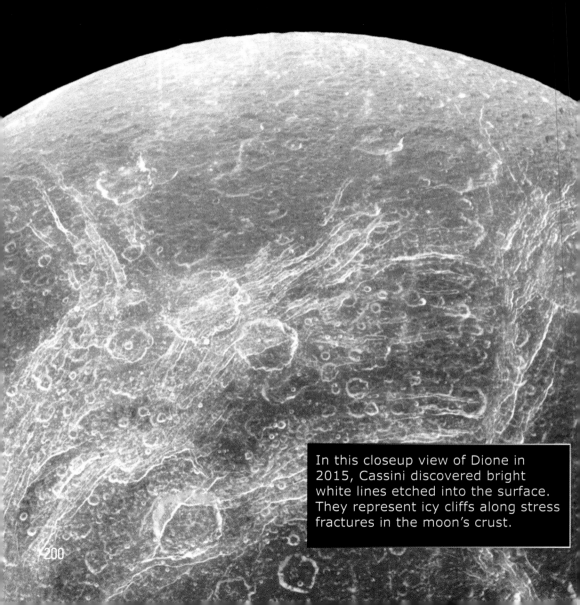

In this closeup view of Dione in 2015, Cassini discovered bright white lines etched into the surface. They represent icy cliffs along stress fractures in the moon's crust.

200

Hyperion is a small, spongy, irregularly-shaped moon that rotates chaotically as it orbits Saturn. Cassini took this image in 2005.

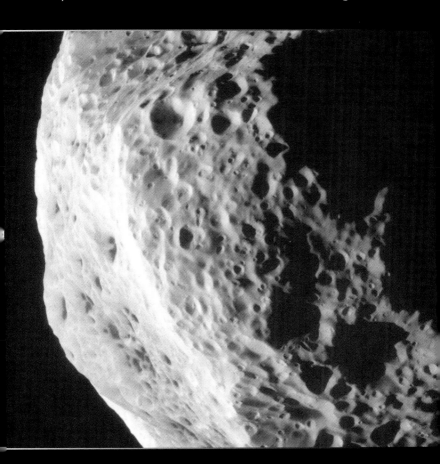

Titan

In January 2005, the Cassini mission dropped the Huygens probe onto the surface of Titan, Saturn's largest moon. The probe discovered a fascinating place: unlike any other moon in the solar system, Titan has a thick and opaque atmosphere. It is composed mostly of nitrogen, with some methane and traces of other compounds. It is the only place in the solar system besides Earth to have surface liquids in the form of lakes and rivers.

Titan is larger than the planet Mercury. Below the atmosphere and frozen crust lies a liquid ocean. This subsurface environment fascinates scientists because it could possibly harbor life. The traces of methane in Titan's atmosphere are tantalizing because methane is a telltale metabolic signature of many organisms. Where is the methane coming from? And since sunlight gradually destroys the methane, how is Titan's supply being replenished?

Titan's smoggy atmosphere contrasts with that of other moons. Cassini captured the image in 2009.

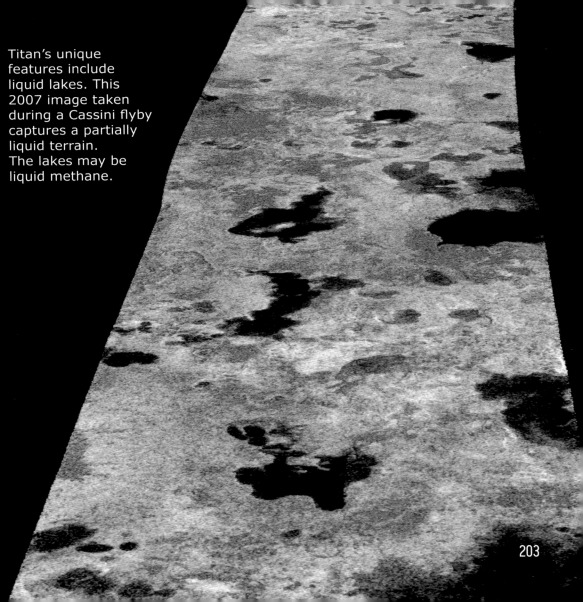

Titan's unique features include liquid lakes. This 2007 image taken during a Cassini flyby captures a partially liquid terrain. The lakes may be liquid methane.

A hazy view of Titan's
many layers.

Titan takes just
under 16 days to
make a full orbit
of Saturn. Like
Earth's Moon,
Titan is tidally
locked, always
showing the
same face to its
parent planet.

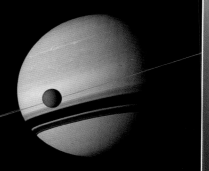

Titan's atmospheric
haze overlays the
edge of pale Dione.

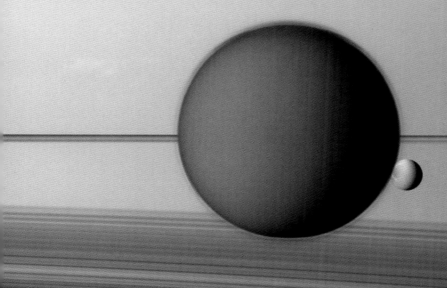

Uranus

Voyager 2's images of Uranus reached us in 1986. Even from a distance of 50,600 miles, the images revealed a near-featureless greenish-blue orb. It has a typical gas giant atmosphere—mostly hydrogen and helium—but also has enough methane to give it its unique tint. Unlike any other planet in the solar system, Uranus rotates on its side.

Voyager 2 also sent us images of a number of moons, revealing a variety of icy worlds, some with notably fractured and uneven surfaces. No spacecraft has visited the system since then.

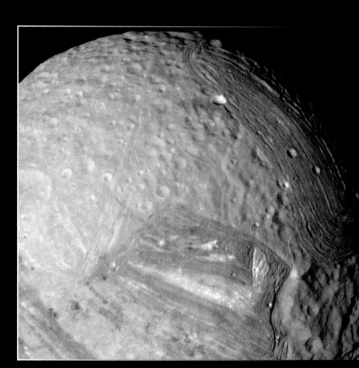

Miranda

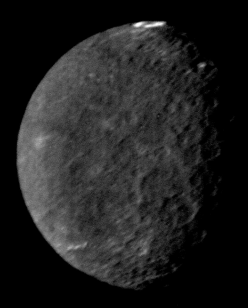

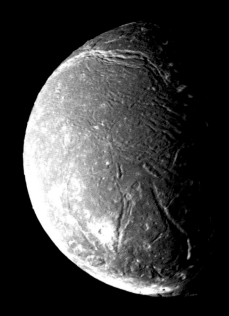

Ariel

Umbriel

208

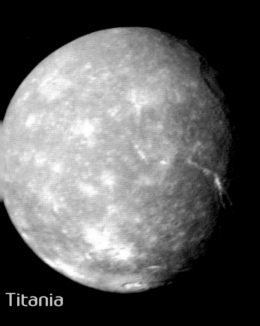

Titania

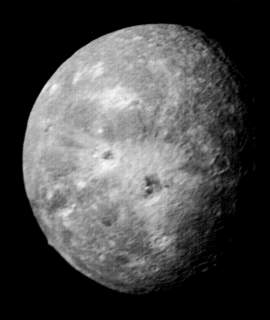

Oberon

Neptune

Voyager 2's last stop in the solar system was the gas giant Neptune. From Earth, Neptune appears to be a dim blue world. The mysterious planet had some surprises for us. The first was that the blue world has winds in its outer layer that move at over 1,000 miles per hour. In fact, the winds on Neptune are the fastest in our solar system. The planet also has different-colored bands that are nearly as pronounced as those on Jupiter. The Voyager mission also sent us back images of storms on the planet that look similar to the Great Red Spot of Jupiter.

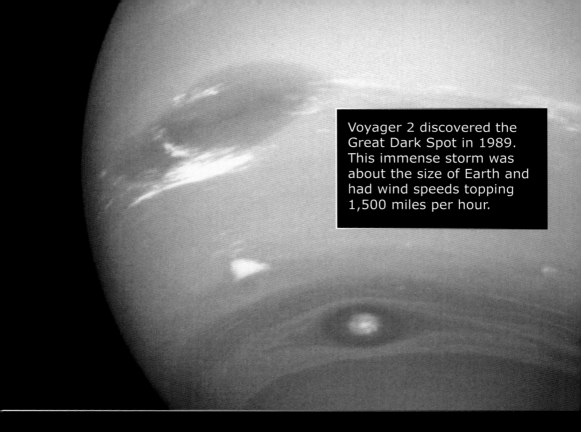

Voyager 2 discovered the Great Dark Spot in 1989. This immense storm was about the size of Earth and had wind speeds topping 1,500 miles per hour.

Voyager 2 confirmed that Neptune has a very thin ring system. These rings are so thin that they are nearly invisible from Earth. The biggest surprise of all was Neptune's moon Triton. Images showed dark eruptions on the surface that looked a lot like geysers. Scientists later determined these were eruptions of nitrogen from beneath the icy polar caps.

Voyager 2 took this image of streaking cloud bands when it was two hours away from its closest approach to the gas giant.

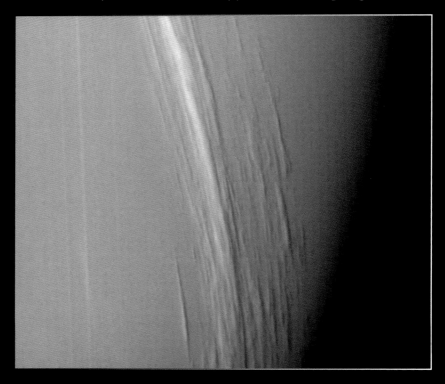

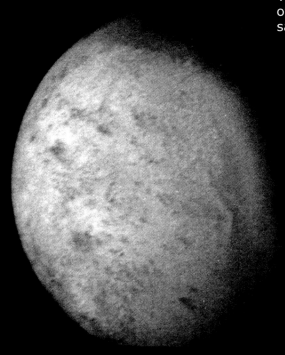

Voyager 2 took this image of Neptune's largest satellite, Triton, in 1989.

Dwarf Planets

Astronomer Clyde Tombaugh discovered Pluto in 1930. In more recent years, researchers have found many problematic bodies in our solar system. Scientists were faced with either assigning planetary status to many more bodies or reclassifying Pluto. In 2006, the International Astronomical Union stipulated that planets have to fulfill the following criteria:

1) the body must orbit the Sun
2) the body must be big enough for gravity to quash it into a round ball
3) the body must have cleared all other debris (including asteroids and comets) out of its orbit

Pluto was reclassified as a dwarf planet because it did not fulfill the third criterion. The reclassification was controversial to some astronomers, however. Many contend that Earth, Mars, Neptune, and Jupiter have not cleared their orbits either. Pluto actually ventures into Neptune's

True color global view of Pluto, taken by New Horizons in 2015.

orbit at times, and there are 10,000 asteroids in Earth's orbit and 100,000 in Jupiter's. The debate continues.

Astronomers are aware of dozens of other dwarf planets, and the number is expected to grow. As of 2014, the International Astronomical Union (IAU) recognizes five dwarf planets (Pluto, Eris, Ceres, Haumea, MakeMake) with some astronomers asserting this number should be even higher.

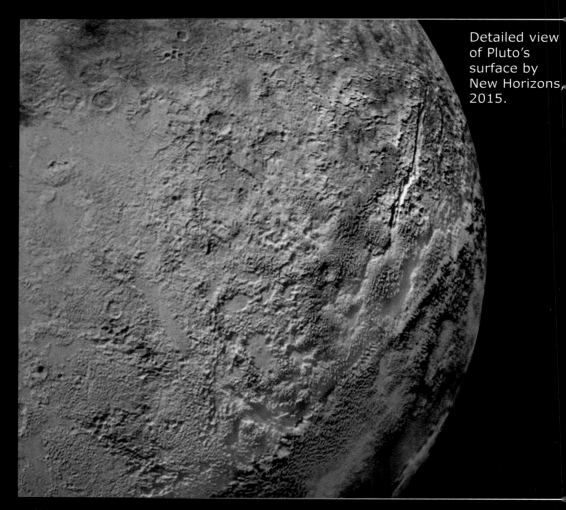

Detailed view of Pluto's surface by New Horizons, 2015.

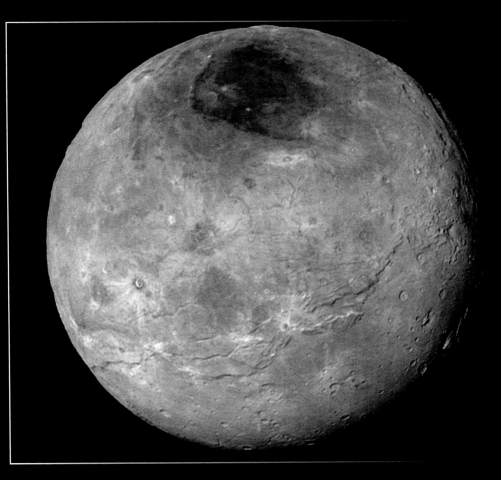

Pluto's moon, Charon, features more geological complexity than might be expected: unusual mountains, sunken plains, and vast tectonic fracture lines.

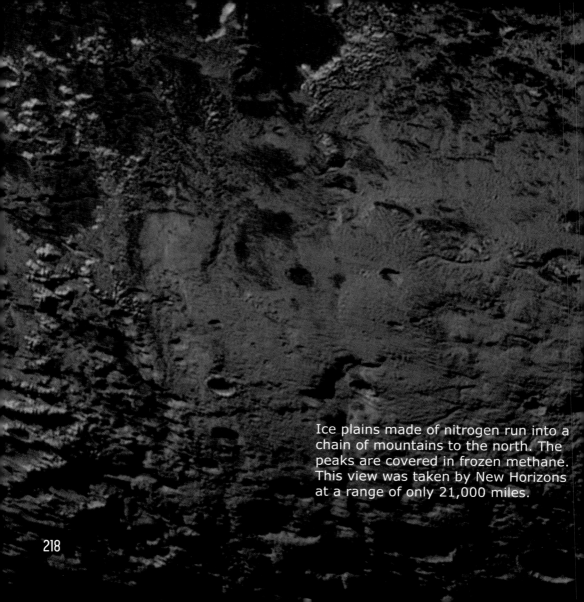

Ice plains made of nitrogen run into a chain of mountains to the north. The peaks are covered in frozen methane. This view was taken by New Horizons at a range of only 21,000 miles.

218

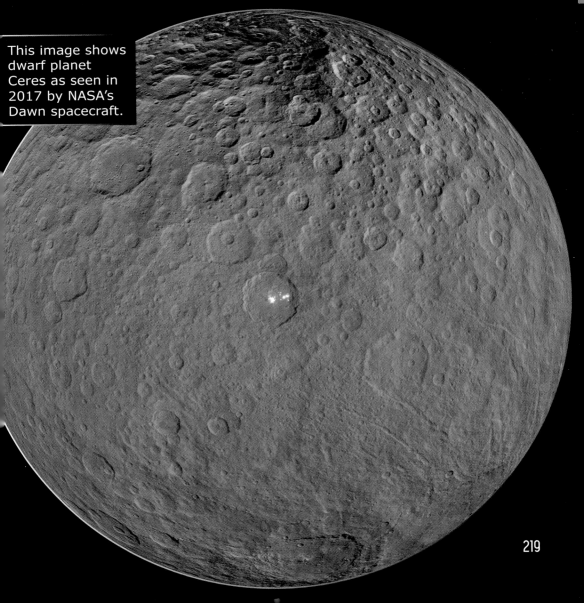

This image shows dwarf planet Ceres as seen in 2017 by NASA's Dawn spacecraft.

219

Comets

Seen from Earth, comets are some of the most extraordinary and transient spectacles in the night sky. But comets are more bluster than substance. In reality, they're just big snowballs made up of rock and dust particles, frozen gases, and ice. Their showy tails are the result of sunlight heating them up as they get nearer to the Sun. These tails can stretch out for millions of miles.

Comets are bits of leftover construction material from the early days of our solar system's creation. Some originate in a vast belt of material beyond the orbit of Neptune. These "short-period" comets take less than 200 years to orbit the Sun. Others, originating farther out in the Oort Cloud, can take literally millions of years to make a single orbit.

This image of comet ISON passing through Virgo was taken at NASA's Marshall Space Flight Center in 2013.

Simple Construction

At its center, a comet contains a nucleus. This tiny frozen core may be no more than a mile across. It is made up of icy chunks mixed with rock, gas, and dust. As the comet approaches the Sun, it develops a second part, called a coma. The coma is a cloud of heated gases. These gases typically consist of water vapor, ammonia, and carbon dioxide. As the comet's orbit brings it ever closer, it grows its final two parts, the dust tail and ion tail. The dust tail is composed of gas and dust. The ion tail is a stream of ionized gases that are blown away from the Sun as the comet comes in contact with the solar wind.

Hubble snapped this image of ISON in 2017. The comet's nucleus is blue, while the tail has a redder hue.

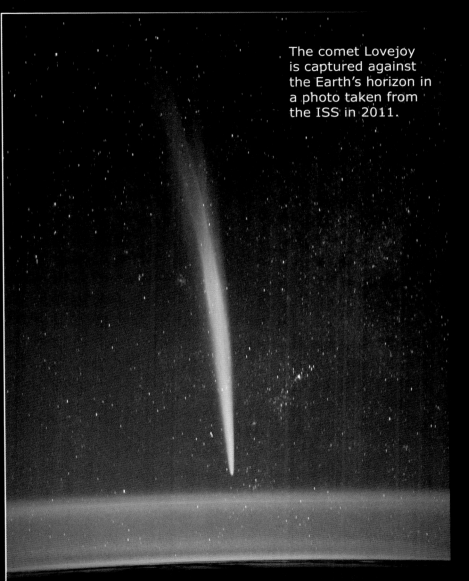

The comet Lovejoy is captured against the Earth's horizon in a photo taken from the ISS in 2011.

223

A blur and it's gone. In 1986, the European spacecraft Giotto got close enough to capture this image of the iconic Halley's comet (enveloped in its coma) as it headed away from the Sun.

Landing on a Comet

The European Space Agency's Rosetta mission was launched in 2004. It was the first mission to successfully land a probe on a comet. The target comet was 67P/Churyumov-Gerasimenko. The controlled impact occurred in 2016.

The landing was complicated by the fact that the comet was shaped like two lopsided balls, with a smaller mass joining them. The flight team carefully maneuvered the spacecraft closer and deployed the lander. Seven hours later, contact with the comet was confirmed. Unfortunately, the lander bounced. It drifted across the comet's surface before halting against a cliff face. Even so, the mission was able to initiate its science sequence and send back analyses of soil and gas samples. It found an array of compounds important for the formation of prebiotic material. In other words, we now know that the chemical building blocks of life can be found in comets.

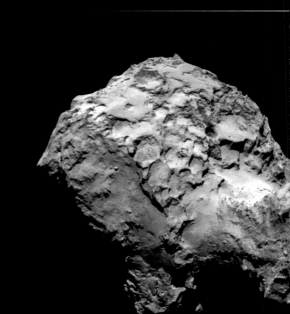

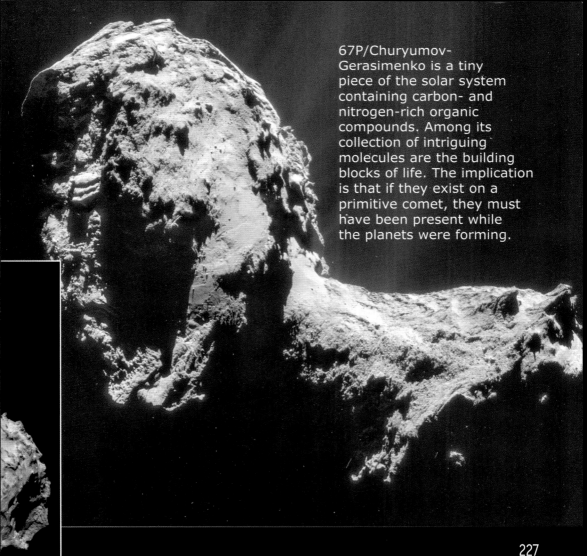

67P/Churyumov-Gerasimenko is a tiny piece of the solar system containing carbon- and nitrogen-rich organic compounds. Among its collection of intriguing molecules are the building blocks of life. The implication is that if they exist on a primitive comet, they must have been present while the planets were forming.

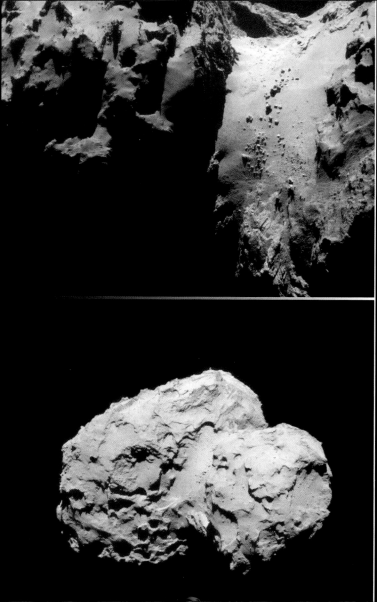

Size and distance can be deceptive when there's nothing familiar nearby to help determine scale. 67P/Churyumov-Gerasimenko is actually several miles across on its long side, making it comparable to a medium-sized Earth mountain.

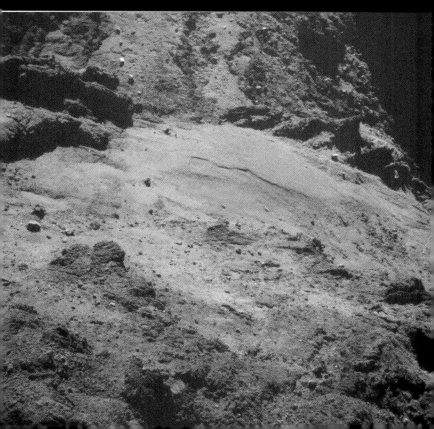

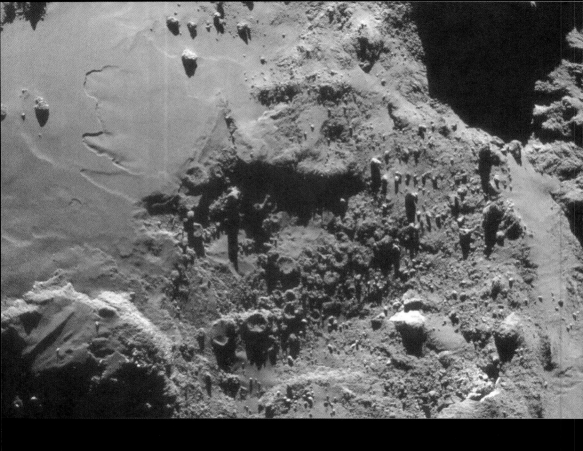

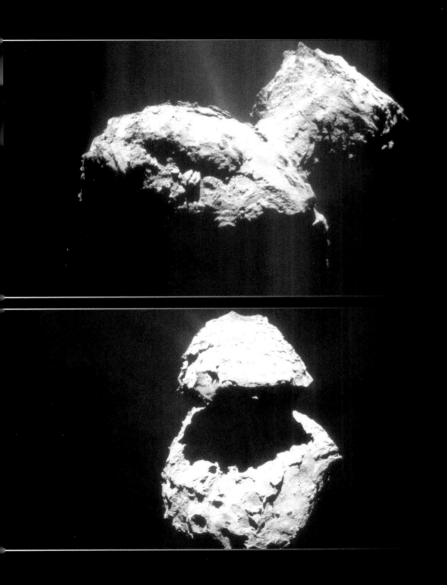

Shooting Stars

A meteoroid is a small piece of matter—a chunk of rock or a particle of dust—drifting through space. Once this debris enters Earth's atmosphere, it is known as a meteor. Commonly called shooting stars, meteors are easy to spot. Anyone who spends enough time staring up into the clear night sky will eventually see one. As a meteor enters the atmosphere it is heated by tremendous friction, which then causes it to glow and leave behind a bright trail of incandescence.

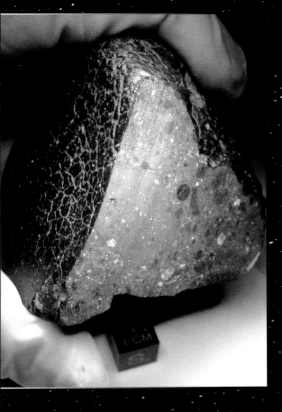

Meteors that reach the ground are called meteorites. Many meteorites originate in the asteroid belt. However, this meteorite—discovered in the Sahara Desert—came from Mars. It is about 2.1 billion years old and was probably ejected from that planet by the impact of a large object like an asteroid.

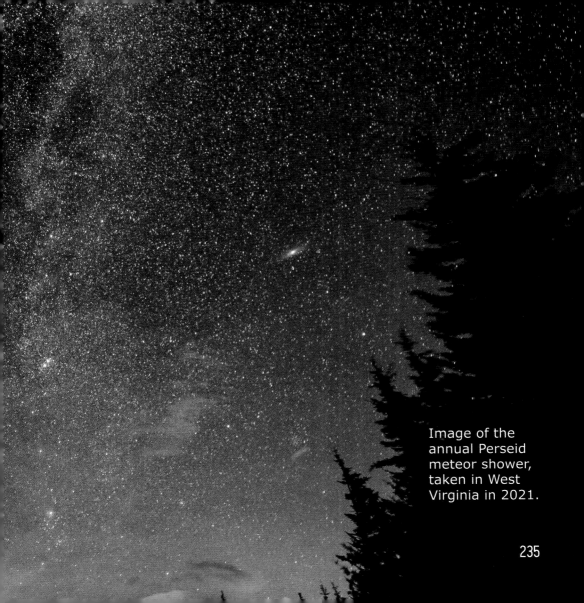

Image of the annual Perseid meteor shower, taken in West Virginia in 2021.

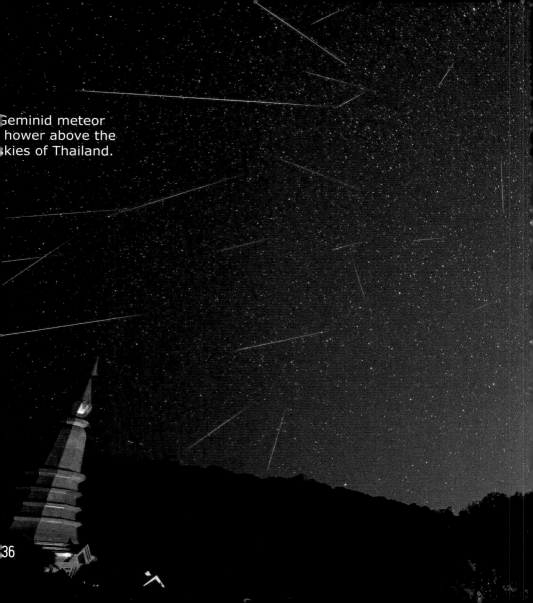

Geminid meteor
shower above the
skies of Thailand.

36

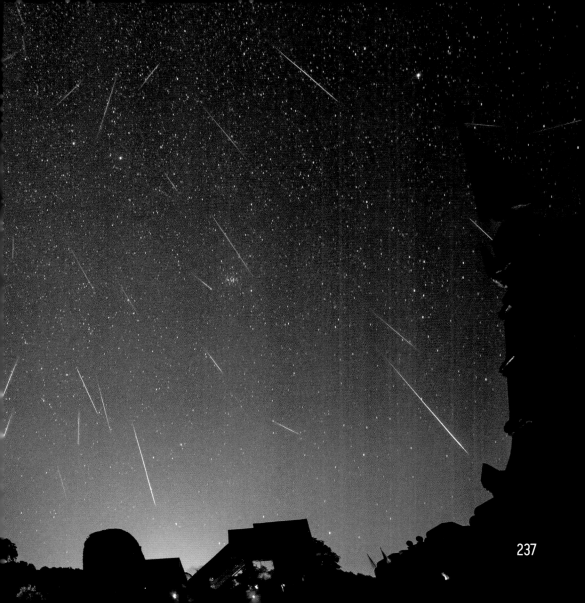

The Sun

The Sun is the largest object in our solar system, accounting for over 99 percent of its mass. It is classed as a yellow dwarf and is roughly 4.5 billion years old. The energy that it generates—the energy that makes life on Earth possible—originates from a nuclear fusion process in its core. This energy then moves outward, radiating across the solar system.

The Sun is made up of layers. Outside of the energy-producing core is a vast region known as the radiation zone, where energy slowly moves outward via interaction with surrounding atoms. It is a slow process; photons bounce from particle to particle for thousands of years before making their way to the next region, called the convection zone. This outer layer is cooler, allowing for material to move from hotter to cooler areas. This material follows a direct path outward, meaning that energy is transferred much faster.

The Sun has something like a surface atmosphere as well. These are divided into three regions: the photosphere, the chromosphere, and the solar corona. The photosphere is the

visible surface and the area containing observable features like sunspots and granules. Above this, the chromosphere extends outwards for over 1,000 miles. It gradually merges with the corona. Solar filaments and prominences can be seen rising through these two layers.

Three telescopes were used to capture the dynamic nature of the Sun's surface: NASA's Nuclear Spectroscopic Telescope Array (NuSTAR) reveals high-energy X-rays in blue, Japan's Hinode captures low-energy X-rays in green, and NASA's Solar Dynamics Observatory (SDO) reveals the rest in yellow and red. The composite image was taken in 2015.

Solar Flares

NASA's Solar Dynamic Observatory (SDO) took this image in 2013. The darkness at the top right of the Sun's face is a coronal hole—the origin of solar wind leaving the Sun.

Solar flares begin with the release of magnetic energy in the solar atmosphere. Huge magnetic loops, called prominences, sometimes collide with each other, setting off a solar flare event. They are often related to sunspot activity. They can last from several minutes to several hours.

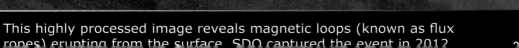

This highly processed image reveals magnetic loops (known as flux ropes) erupting from the surface. SDO captured the event in 2012.

NASA's Solar Terrestrial Relations Observatory (STEREO) caught this image of a massive solar filament snaking around the Sun in 2010.

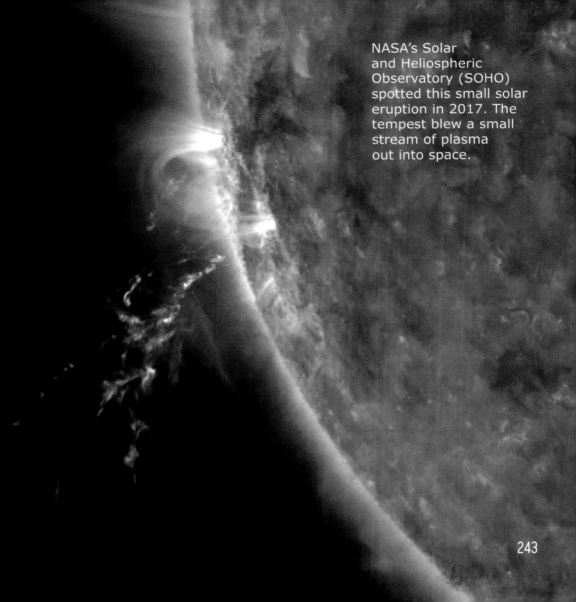

NASA's Solar and Heliospheric Observatory (SOHO) spotted this small solar eruption in 2017. The tempest blew a small stream of plasma out into space.

In 2003, SOHO captured this intense solar flare burst.

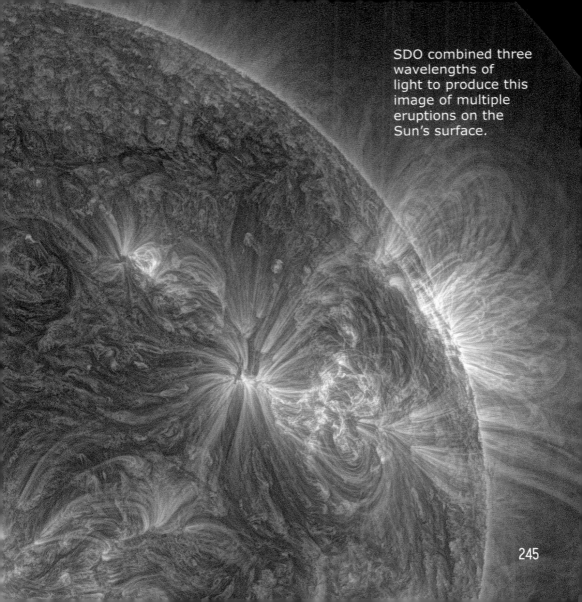

SDO combined three wavelengths of light to produce this image of multiple eruptions on the Sun's surface.

245

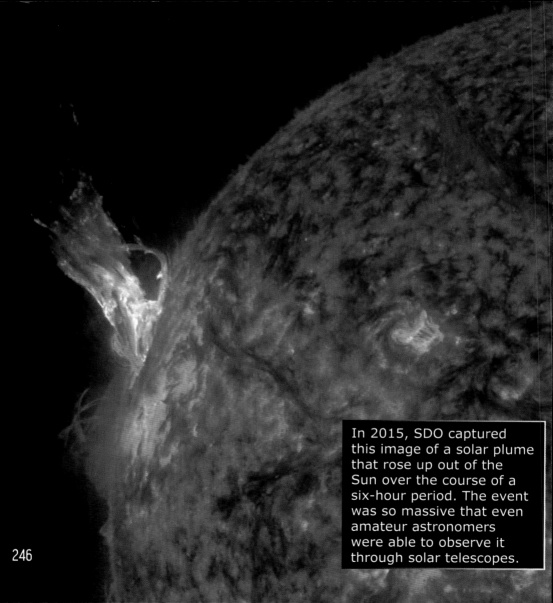

In 2015, SDO captured this image of a solar plume that rose up out of the Sun over the course of a six-hour period. The event was so massive that even amateur astronomers were able to observe it through solar telescopes.

This massive plume of
spinning plasma was
spotted by SDO in 2015.

247

SDO discovered a gigantic sunspot covering almost 80,000 miles of the Sun's surface in 2014. Sunspots indicate the presence of intense magnetic fields. They are prime locations for the outburst of solar flares.

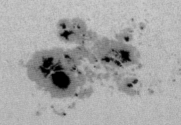

249

A total solar eclipse seen above Oregon in 2017. A solar eclipse happens when the moon moves between the Earth and the Sun.

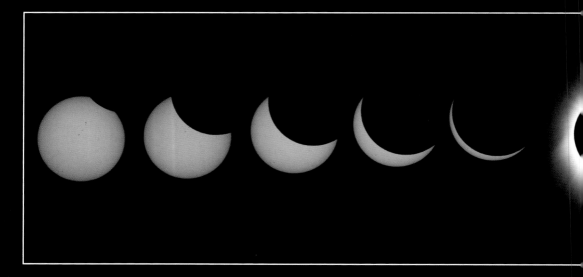

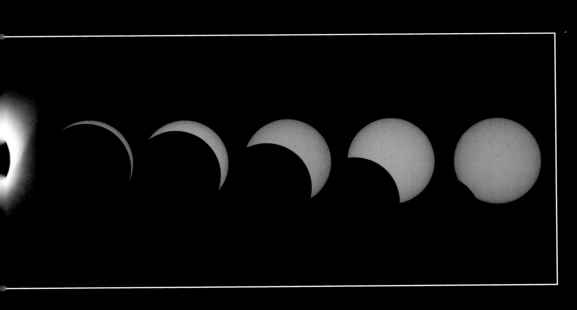

Stars

Stars originate in clouds of interstellar gas and dust. As clouds clump together and attract more mass, they begin to collapse under gravitational attraction and heat up. Eventually they become protostars—hot balls of gas waiting to ignite and become newborn stars. Our Sun went through this process billions of years ago, eventually becoming a yellow dwarf. The Sun is neither the largest, the smallest, nor the most unusual type of star. Beyond our solar system there are many other star types, some with very surprising attributes.

Astronomers classify stars based on their size, color, temperature, and luminosity. The Hertzsprung-Russell diagram is one of the most useful charts for understanding star varieties.

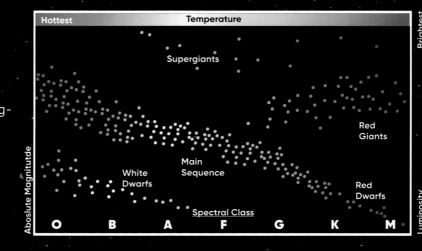

Possibly only a few hundred thousand years old, the binary protostar LRLL 54361 lies at the heart of this star-forming cloud. The Spitzer Space Telescope detected the object in 2013.

The Hubble Space Telescope zoomed in on this ancient globular cluster in 2004–05. At 13.4 billion years old, this cluster is old enough to have come into being when the universe was young. Old stars predominate: the red stars are giants that expanded as they exhausted their supply of hydrogen. The blue stars have also consumed their hydrogen and are now using helium as an energy source.

The Hubble Space Telescope used its near-infrared camera to reveal this nursery of over 300 young stars in the Orion Nebula's Trapezium cluster. The dim reddish stars around the periphery are brown dwarfs—stars usually too dim to see. These ones are young, however (about 1 million years old), and burning just brightly enough to observe.

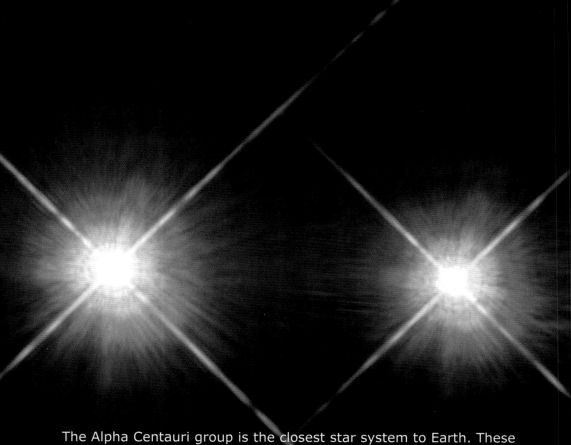

The Alpha Centauri group is the closest star system to Earth. These three stars are about 4.3 light-years away. They consist of Alpha Centauri A (a G star slightly larger than our Sun), Alpha Centauri B (a K star slightly smaller than our Sun), and Alpha Centauri C (an M star red dwarf). The two larger stars are seen here.

Some stars are massive and hot enough to create stellar winds that are epic in scale. The vast bubble seen here is seven light-years across. It was created by a star 45 times larger than our own Sun. As hot gases escape outward, they encounter cold interstellar gases that pile up in front of the wave. This star is relatively young. It will become a supernova in 10 to 20 million years.

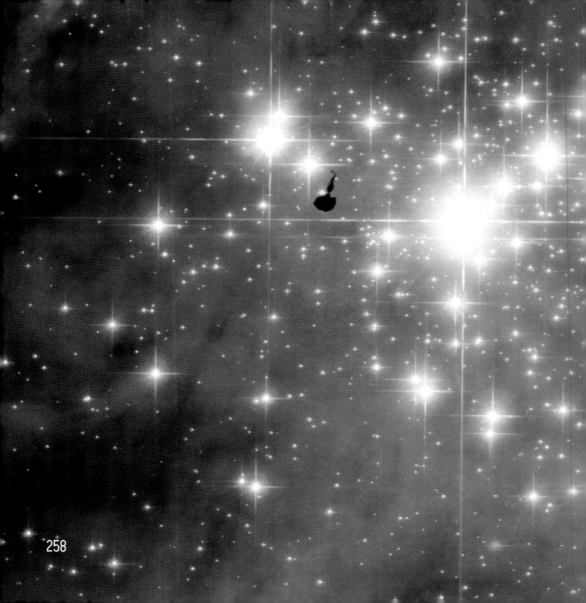

258

This collection of white dwarfs is located in a globular star cluster 5,600 light-years away. At 12-13 billion years old, they are some of the most ancient stars in the Milky Way. Average stars like the Sun eventually become white dwarfs when they reach their final burnt-out state.

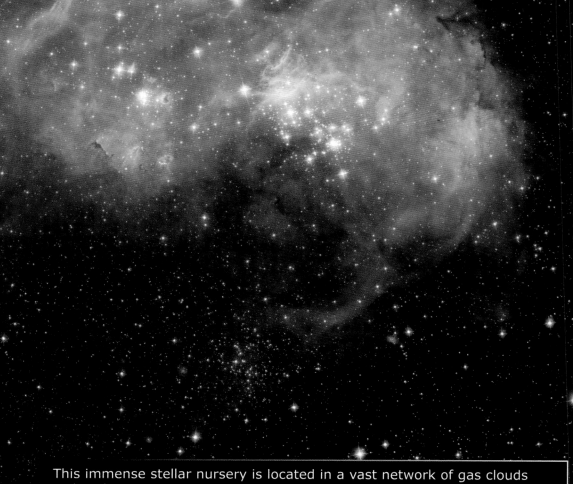

This immense stellar nursery is located in a vast network of gas clouds within the nearby galaxy Large Magellanic Cloud. The area, known as N11, is 1,000 light years across.

This colorful old globular cluster is tucked away in the Large Magellanic Cloud. Prominent among the white dwarfs and red giants is a gleaming red carbon star (lower left of the cluster). Carbon stars are usually red giants. These stars appear a deep ruby red to us due to the carbon in their atmospheres. Carbon stars have run out of hydrogen and use helium as their energy source. This produces the carbon and oxygen that passes into the star's outer layers.

A planetary nebula is simply an expanding shell of luminous gases thrown off by a star. The phenomenon occurs when a star can no longer support itself via fusion in the core. The star suddenly shrinks and thermonuclear reactions move to the star's helium shell. Outward radiation pressure begins to exceed the inward pull of gravity. Once the outer portions of the star begin to separate, they do so in speedy and spectacular fashion. The ejected gas hurtles outward, illuminated from within by radiation from the still-burning star. The remnant star is a white dwarf.

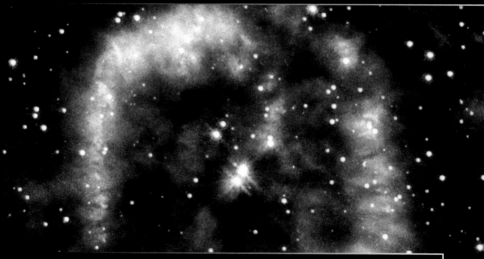

Planetary nebula PK 329-02.2 (also called Menzel 2, after the astronomer, Donald Menzel, who first noted it in 1922) is about 8,000 light-years away.

William Herschel named the Eskimo Nebula (technically named NGC 2392) in 1787. From his telescope, the planetary nebula had the appearance of a human head surrounded by a parka hood.

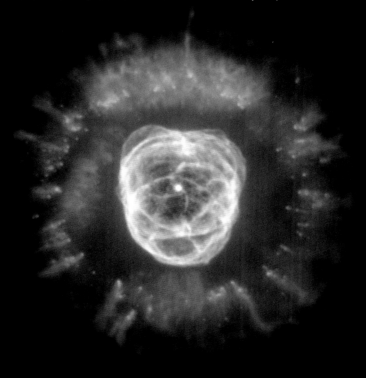

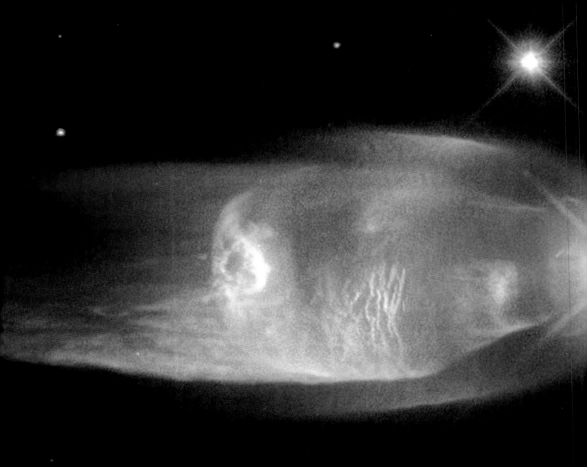

Bipolar planetary nebulas like the Twin Jet Nebula (technically named PN M2-9) can develop from binary star systems. The lobes are extremely young—barely over a thousand years old.

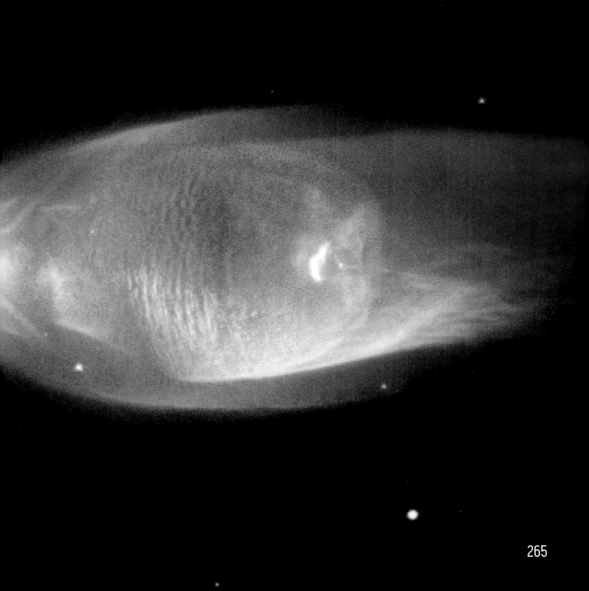

MyCn18 is another example of a fairly young planetary nebula. Its hourglass shape may be due to the fast expansion of stellar winds at the poles while denser clouds around the equator move outward more slowly.

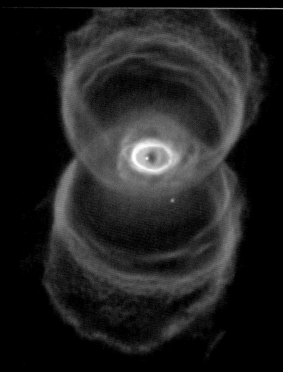

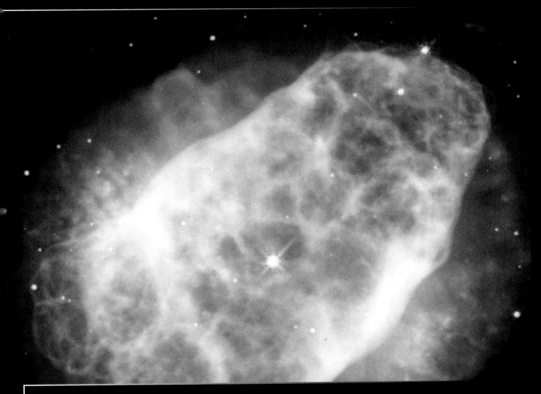

Planetary nebula NGC 6153 is located about 4,000 light-years away. The gauzy white cloud is notable for containing high amounts of neon, argon, oxygen, carbon, and chlorine. The original cloud of material that created the star probably already contained a lot of these elements.

The Cat's Eye Nebula (technically named NGC 6543) presents one of the most complex shapes ever observed. One theory suggests that the star cast out these bubbles of gas in pulses.

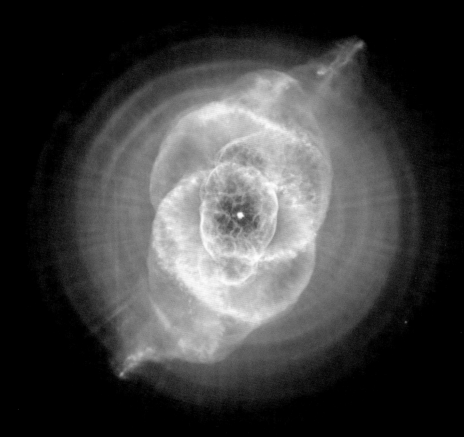

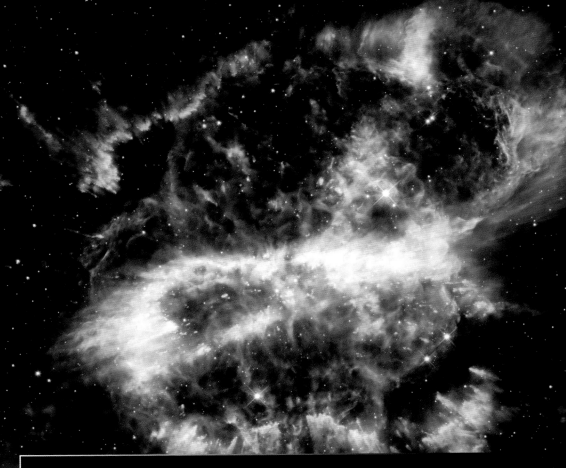

Not all stars make symmetrical transitions. The planetary nebula NGC 5189 probably expanded messily due to an uneven ejection of star mass.

The odd shape of IC 4406 is due to our end-on viewing angle. From another point in space, this planetary nebula would appear as a ring-shaped cloud of glowing gas.

Nova or Supernova

A typical nova begins in a binary system. A white dwarf orbiting a larger star begins to siphon that star's outer layer of gas. When enough gas builds up around the white dwarf, a thermonuclear chain reaction occurs. The explosion can cause the system to shine a million times brighter than normal. This outburst can happen multiple times if the white dwarf continues to steal gas.

A supernova is even more violent. A Type I supernova also involves a white dwarf stealing gas from a companion star. In this case, the white dwarf's dead core reignites in an explosion that destroys the star. A Type II supernova involves a star much more massive than our Sun. When this star runs out of fuel, it collapses under its own gravity and then explodes. A Type II supernova may leave behind a neutron star, pulsar, or black hole.

SN 1987A is a titanic Type II supernova that appeared in the night sky in 1987. Astronomers theorize that the shockwave of the supernova has caught up with a ring of previously expelled clumps of gas, illuminating it like a cosmic pearl necklace.

273

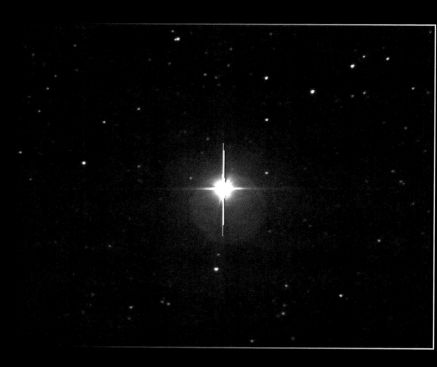

When visible from Earth, a nova appears quite suddenly as a very bright star. The brightness will fade over time. Seen here, Nova Velorum 1999 could be seen in that year from the southern hemisphere only, becoming one of the brightest objects in the sky.

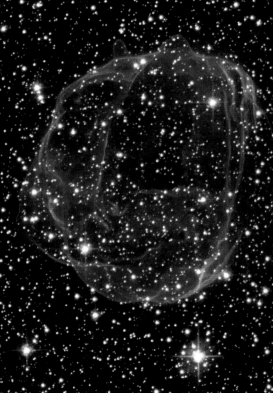

SNR 0519 is about 150,000 light-years away, in the Large Magellanic Cloud. The supernova remnant is fairly young—its progenitor star exploded 600 years ago.

The Homunculus Nebula is a two-lobed phenomenon surrounding the Eta Carinae system. The largest star in the system is near the end of its life and underwent a "supernova imposter event" observed by astronomers in 1843. It stopped short of destroying the star, but at some point in the next million years it will go supernova for real.

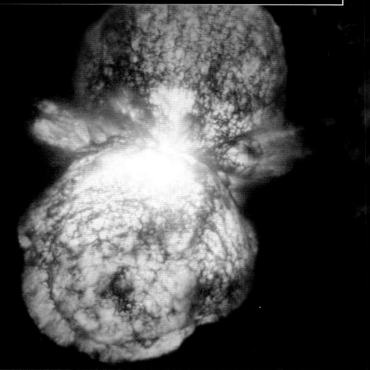

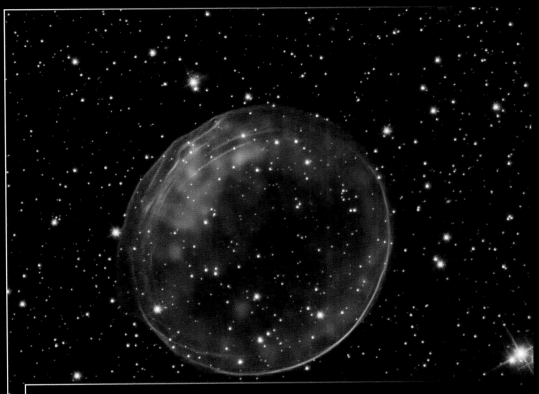

The expanding shock wave of SNR 0509-67.5 appears as a red outline circling greens and blues (representing heated gas). Both the Hubble Space Telescope and the Chandra X-ray Observatory were enlisted to create this composite image. The supernova remnant is about 23 light-years across.

NASA's Chandra X-ray Observatory took this close
look at the ejecta around GK Persei, a white dwarf
that went nova in 1901. The nebula surrounding the
star is called a nova remnant. Nova remnants create
less mass and energy than planetary nebulas.

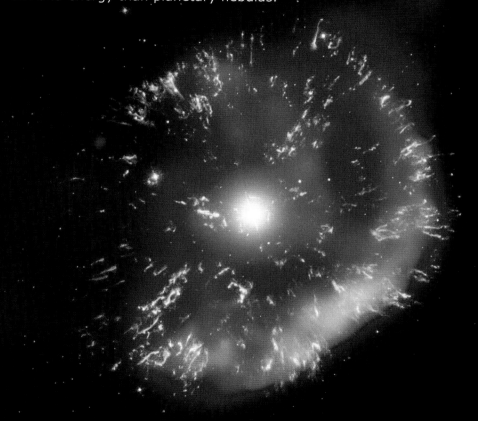

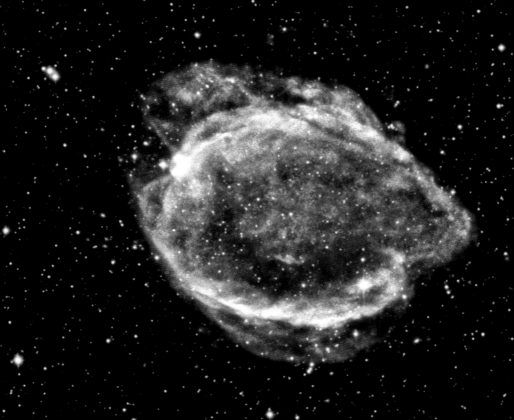

This great stellar bubble is about 16,000 light-years away. G299.2-2.9 is the supernova remnant of a star that exploded about 4,500 years ago.

279

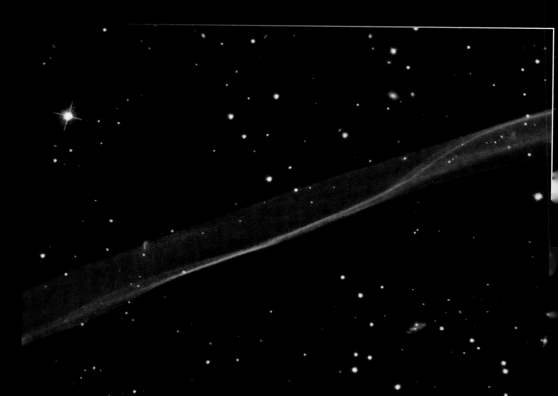

NASA's Hubble Space Telescope captured this well-defined ribbon of gas, part of a supernova remnant that is only about a thousand years old. The supernova was a memorable event to observers on Earth. Reports from Africa, Asia, and Europe indicate the supernova became the brightest object in the night sky and was even visible during the day for several weeks.

Looking more like something dwelling in the cold depths of the ocean than interstellar space, this immense supernova remnant is composed of superheated gas and debris. The expanding shock wave is outlined in blue. We know exactly when the supernova occurred: many observers, including astronomer Tycho Brahe, noted the event in 1572.

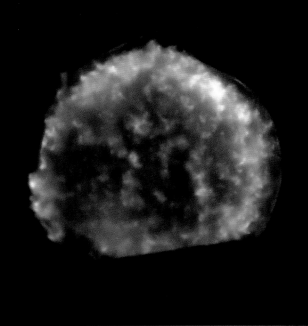

Supernova remnant E0102-72 is about 190,000 light-years away, in the Small Magellanic Cloud. Though it appears perfectly spherical from our perspective, the explosion actually created an unusual cylindrical shape.

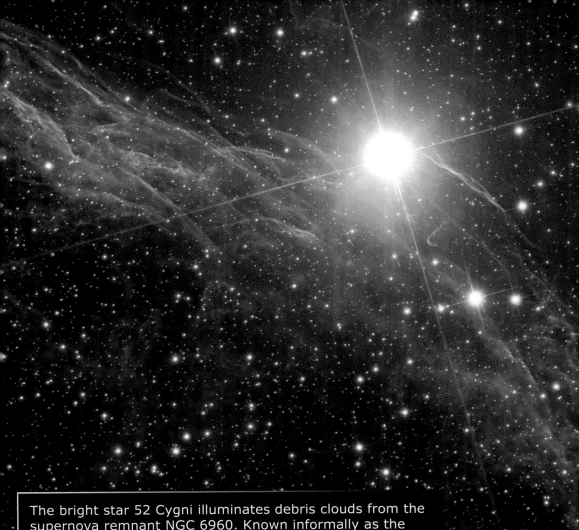

The bright star 52 Cygni illuminates debris clouds from the supernova remnant NGC 6960. Known informally as the Witch's Broom Nebula, it is part of the larger Veil Nebula.

283

Neutron Stars

A star of just the right size will end its life as a neutron star. Once it has exhausted its hydrogen fuel, converted its core to iron, and blown its outer shell in a supernova event, the force of gravity on the collapsing core becomes strong enough to merge electrons with protons. The resultant super-compressed ball of neutrons is about the size of a city.

Neutron stars are some of the most rapidly rotating stellar objects, and have the highest magnetic fields ever observed. The matter they're made of is so condensed that a small handful would weigh millions of tons.

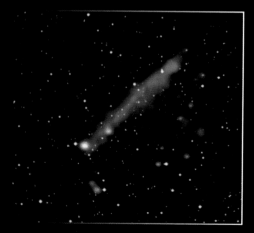

Since neutron stars are not light-producing via nuclear reactions, we observe their radiation with radio telescopes. The regular spin of the star makes it appear to

NASA's Chandra X-ray Observatory discovered that this spinning neutron star has a long X-ray tail. The pulsar itself is at the upper right end of the tail.

pulsate with radiation. A neutron star of this type is called a pulsar. Pulsars emit constant beams of radiation, like lighthouse beacons.

When the first pulsar was discovered, astronomers dubbed it LGM-1—short for Little Green Men-1. The pulses seemed artificial because they were timed so perfectly. Astronomers joked that they were signals from aliens. We now know that pulsars are great timekeepers—they rotate at extremely precise intervals, from once every few milliseconds to once every ten or more seconds.

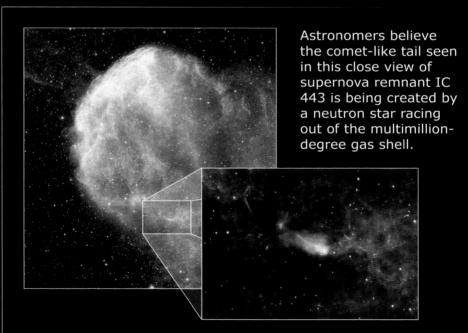

Astronomers believe the comet-like tail seen in this close view of supernova remnant IC 443 is being created by a neutron star racing out of the multimillion-degree gas shell.

An extremely powerful pulsar lies at the center of the Crab Nebula, beaming jets of charged particles. The Chandra X-ray Observatory captured this image. A bright ring of high-energy particles radiates from the equatorial region of the pulsar.

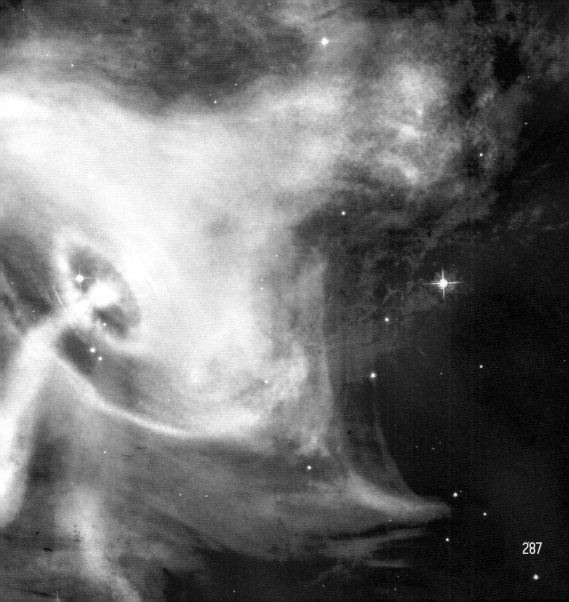

287

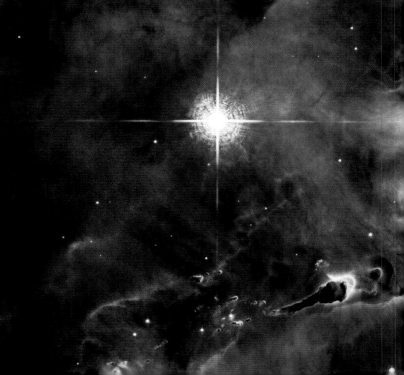

The Interstellar Medium

What's out there, in between the stars, planets, supernova remnants, and wayward comets? Usually not much but cold vacuum. But molecular gas and dust does drift through the empty spaces. If there are nearby stars to illuminate the material, the view can be awe-inspiring.

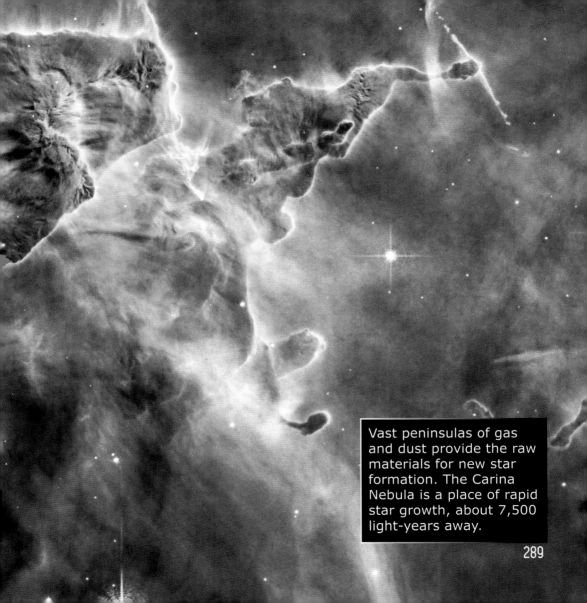

Vast peninsulas of gas and dust provide the raw materials for new star formation. The Carina Nebula is a place of rapid star growth, about 7,500 light-years away.

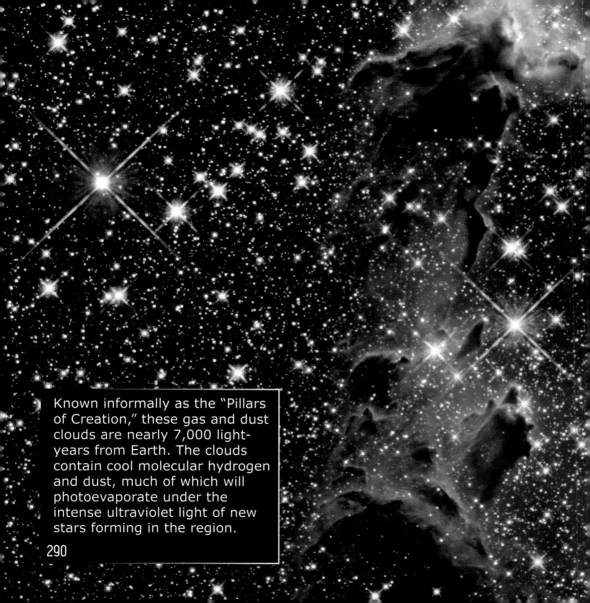

Known informally as the "Pillars of Creation," these gas and dust clouds are nearly 7,000 light-years from Earth. The clouds contain cool molecular hydrogen and dust, much of which will photoevaporate under the intense ultraviolet light of new stars forming in the region.

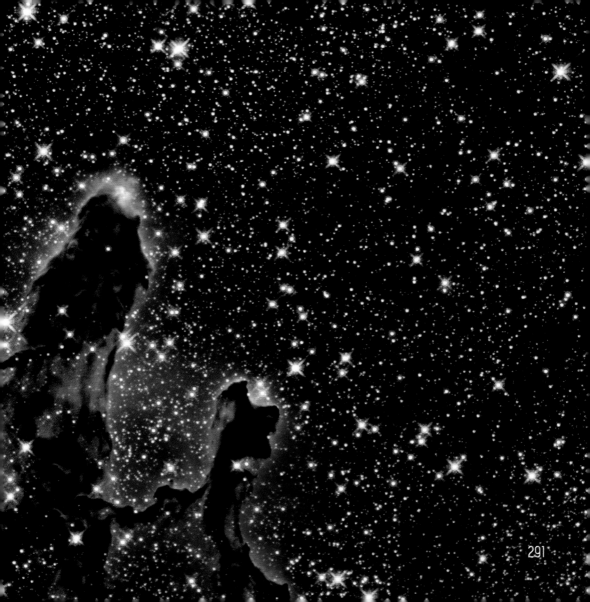

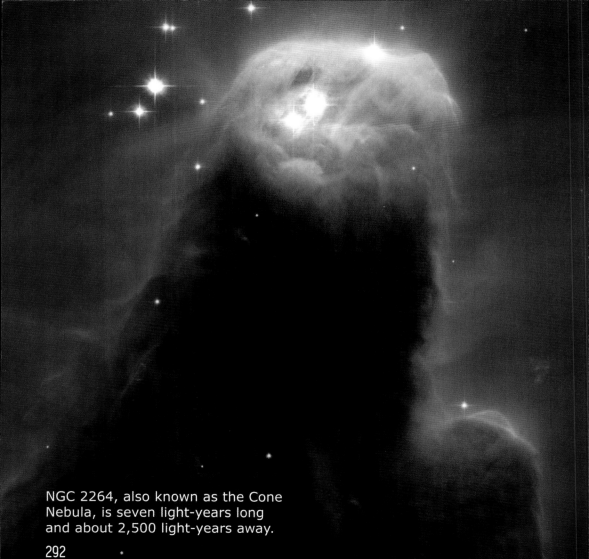

NGC 2264, also known as the Cone
Nebula, is seven light-years long
and about 2,500 light-years away.

With its distinctive shape, the Horsehead Nebula is one of the most iconic molecular clouds known to astronomy enthusiasts. The darker segments are caused by the nebula's thick dust.

Where large amounts of interstellar dust rich in carbon gather, the view can seem reminiscent of chimney smoke. This section of the nebula IC 4603 is part of the Rho Ophiuchus Nebula Complex.

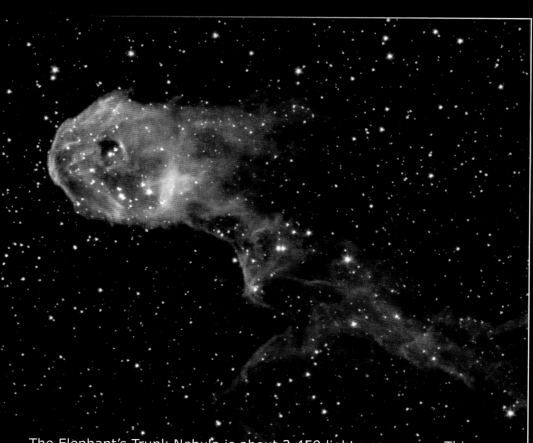

The Elephant's Trunk Nebula is about 2,450 light-years away. This globule of compressed gas is being eroded by ionizing radiation from a nearby star.

The Orion Nebula's glowing gas cloud surrounds a group of hot young stars. The nebula is only 1,500 light-years away, making it one of the closest star-forming regions.

The Eagle Nebula surrounds a vast chamber of young stars that have either eaten or blown away the surrounding gas and dust. The nebula is about 6,500 light-years away and spans about 20 light-years.

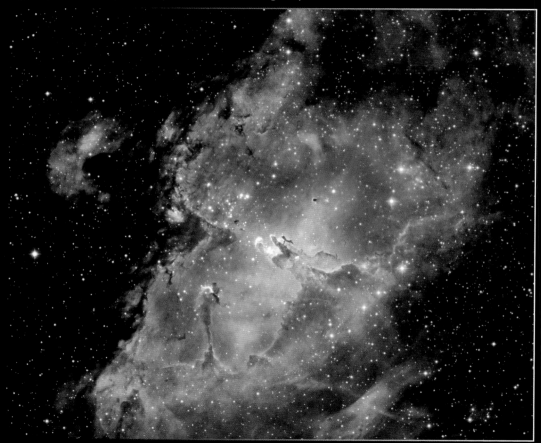

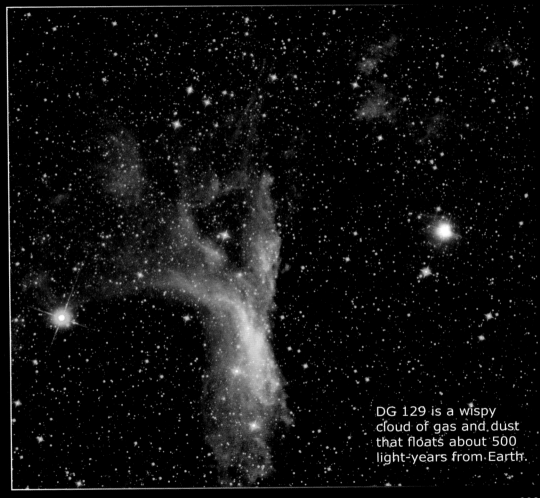

DG 129 is a wispy
cloud of gas and dust
that floats about 500
light-years from Earth.

Galaxies

Our awareness of the nature of galaxies is fairly recent. Early telescopes were able to pick out planets, moons, comets, and stars, but weren't powerful enough to reveal galaxies; they merely appeared as small fuzzy smudges. It wasn't until the 1800s, when telescopes became larger and more powerful, that those smudges revealed themselves to be swirling colonies of stars. We now know that not only are there too many galaxies to count, but they are grouped together into clusters and superclusters.

Generally speaking, there are three types of galaxies: spiral, elliptical, and irregular. A spiral galaxy looks a lot like a child's pinwheel toy, and has a bright center packed with stars, gas, and dust. Spreading out from the center are arms of dust, stars, and stellar nurseries. When viewed from their edges, spiral galaxies look almost flat, with a bump in the middle like a sombrero.

Elliptical galaxies are shaped like eggs, and look like clouds of stars when viewed through a telescope. Elliptical galaxies are thought to be older than spiral galaxies.

Irregular galaxies do not fall
into either category. These
galaxies have unusual shapes—
in some cases the result of
being distorted by the pull of
a larger galaxy. In other cases,
an irregular galaxy may have
been reshaped because of a
collision with another galaxy.

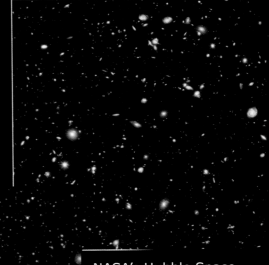

NASA's Hubble Space
Telescope examined
a tiny sliver of the
sky over ten years to
assemble this amazing
portrait of galaxies both
distant and nearby.
Some of the faintest
galaxies in the image are
only one ten-billionth the
brightness a human eye
can perceive.

NGC 6744 is a spiral galaxy similar in
appearance to our own.

Spiral galaxy NGC 1433 is about 32 million light-years away. It is a rare type of galaxy known as a Seyfert galaxy. These very active galaxies have centers which are much brighter than normal.

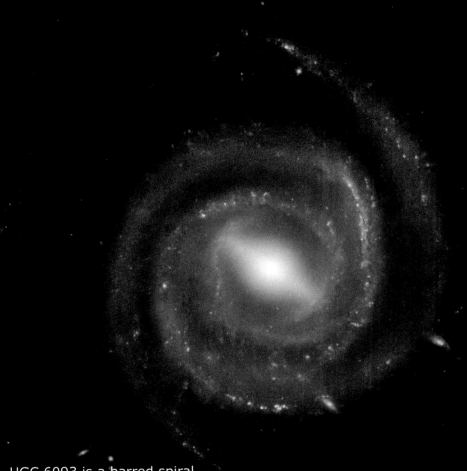

UGC 6093 is a barred spiral
galaxy. Its arms swirl out from
a central bar that bisects the
galaxy's core.

303

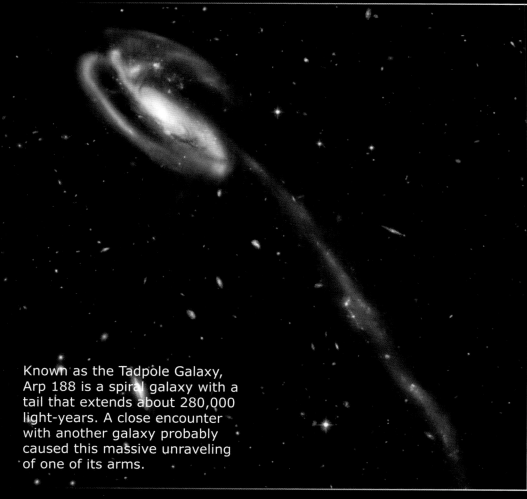

Known as the Tadpole Galaxy,
Arp 188 is a spiral galaxy with a
tail that extends about 280,000
light-years. A close encounter
with another galaxy probably
caused this massive unraveling
of one of its arms.

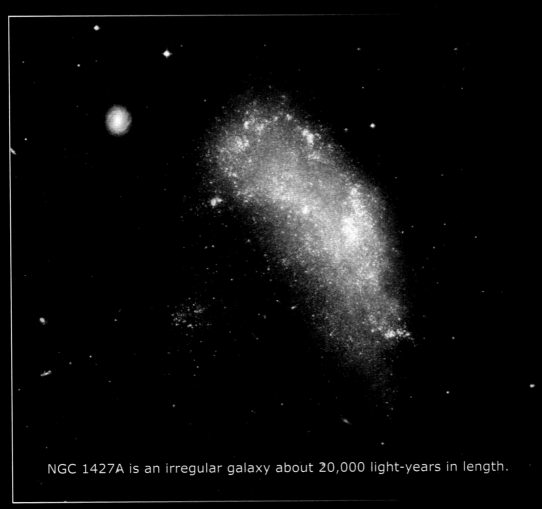

NGC 1427A is an irregular galaxy about 20,000 light-years in length.

This dwarf irregular galaxy, known as PGC 18431, is part of our surrounding galactic neighborhood (the Local Group). This area of space contains about 50 galaxies.

Another member of our Local Group, NGC 6822 is a dwarf irregular galaxy located only about 1.5 million light-years away.

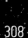

These two colliding galaxies are known collectively as Arp 142. While the galaxy at the bottom appears to retain its elliptical shape, the galaxy at the top was once a spiral, but has been stretched out of shape.

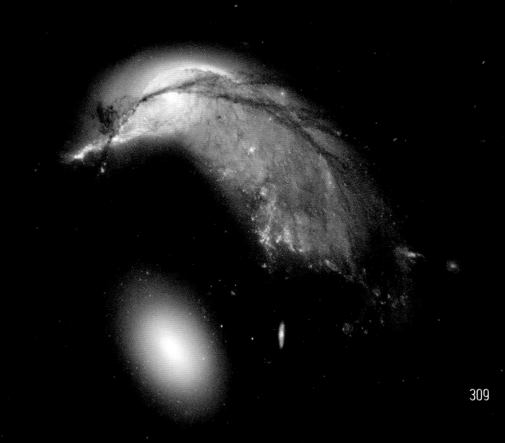

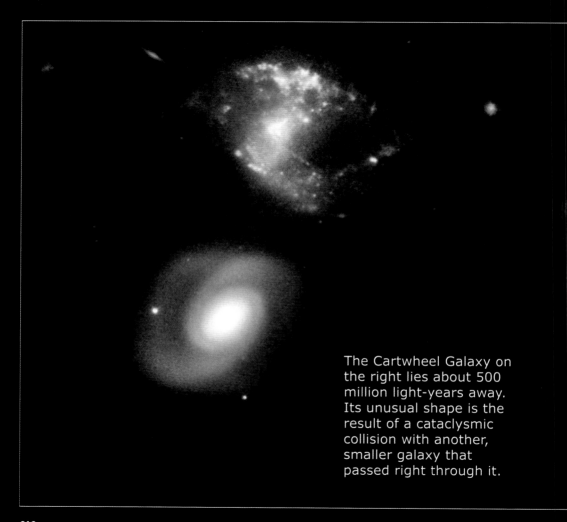

The Cartwheel Galaxy on the right lies about 500 million light-years away. Its unusual shape is the result of a cataclysmic collision with another, smaller galaxy that passed right through it.

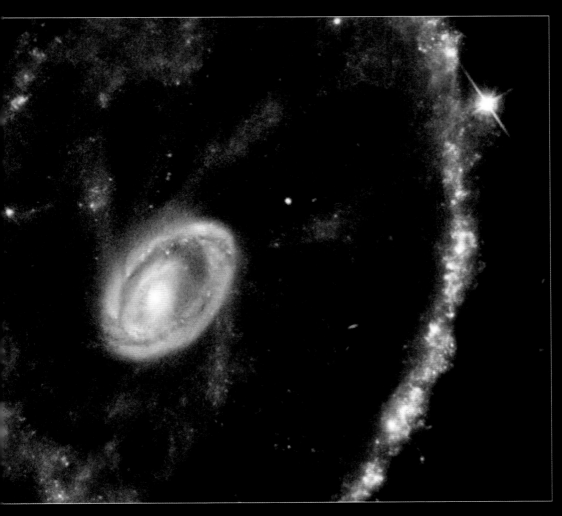

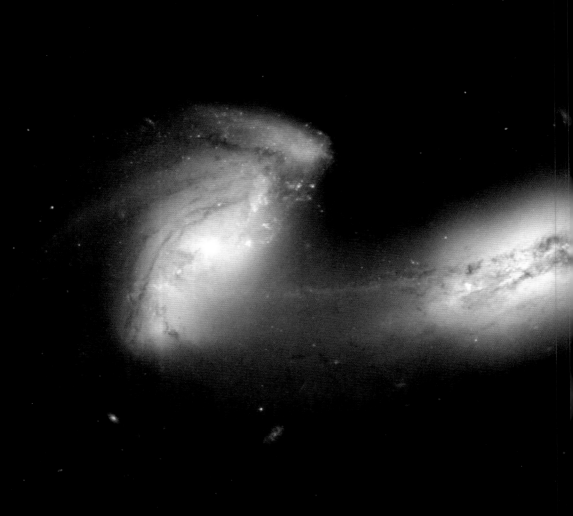

These two nearly-identical spiral galaxies are in the process of merging into one larger galaxy. Nicknamed The Mice, NGC 4676 is about 300 million light-years away.

The Milky Way Galaxy

Our galaxy, the Milky Way, is a barred spiral galaxy. It may contain anywhere from 100 to 400 billion stars and stretches about 100,000 light-years across, though not all estimates agree. The central bulge has a diameter of about 12,000 light-years.

Our galaxy gained its name from the appearance it has in the night sky—a great milky band of light streaming across the sky. It wasn't until the early twentieth century that astronomer Harlow Shapley discovered this band of light was part of our celestial home. Our solar system is situated on the outer edge of one of its arms.

The Milky Way as seen from the International Space Station.

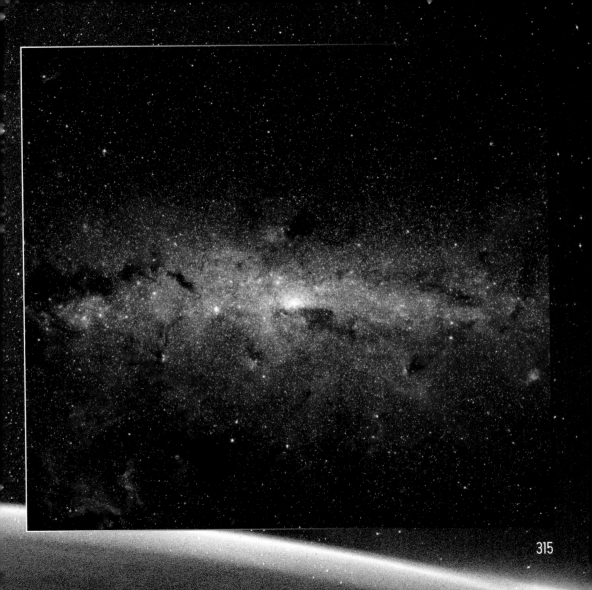

315

Looking directly into the heart of the Milky Way reveals a densely packed stellar neighborhood. The one thing we cannot see is the massive black hole at the center of it all.

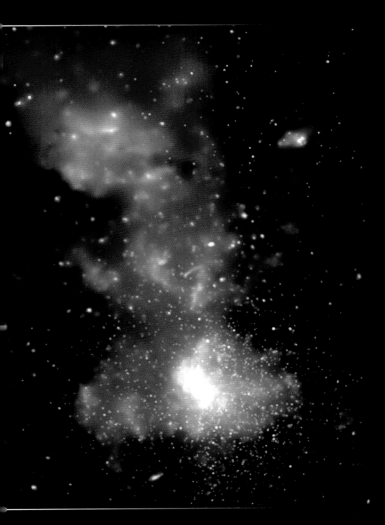

A look into the center of the Milky Way in ultraviolet light gives us another layer of information about activity at the core. Massive star clusters burn brightly, while other mysterious objects like neutron stars and black holes in binary systems show up as small points of light.

NASA's Spitzer Space Telescope selected the infrared spectrum to obtain this view of the stars in our galactic plane obscured by clouds of dust.

In the 1920s, astronomer Edwin Hubble determined that the Andromeda Galaxy was a separate galaxy beyond the Milky Way. Our closest large neighbor, Andromeda is about 2.5 million light-years away and about the same size as our galaxy. It will collide with our galaxy billions of years in the future. The collision will result in a new elliptical galaxy.